SUPER MANGA MATRIX

Hiroyoshi Tsukamoto

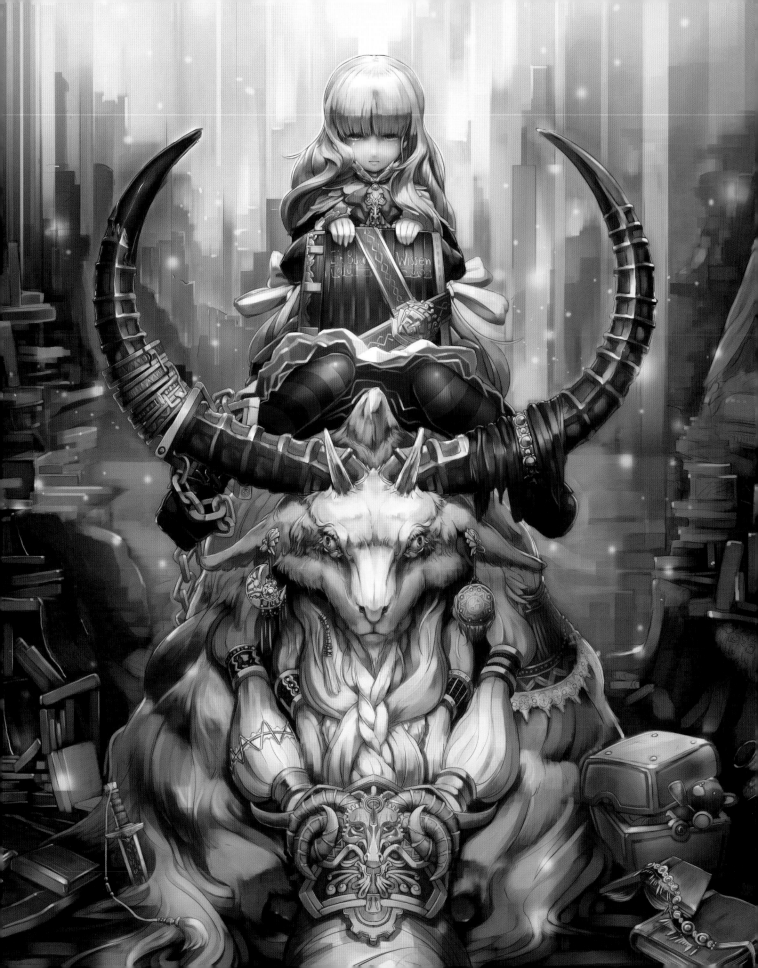

SUPER MANGA MATRIX

Hiroyoshi Tsukamoto

HARPER
DESIGN

An Imprint of HarperCollins Publishers

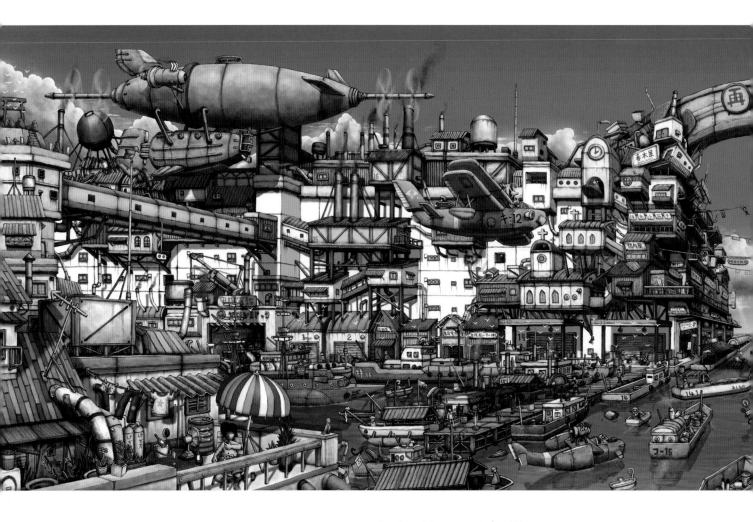

HarperCollins books may be purchased for educational, business,
or sales promotional use. For information, please write:
Special Markets Department, HarperCollins*Publishers*,
10 East 53rd Street, New York, NY 10022.

First published in 2012 by:
Harper Design
An Imprint of HarperCollins*Publishers*
10 East 53rd Street
New York, NY 10022
Tel.: (212) 207-7000
Fax: (212) 207-7654
harperdesign@harpercollins.com
www.harpercollins.com

Distributed throughout the world by:
HarperCollins*Publishers*
10 East 53rd Street
New York, NY 10022
Fax: (212) 207-7654

Front cover illustration: Mio Okada
Book design and art direction: Andrew Pothecary
(forbidden colour)
Editing: Jun Ito (atelier jam)
Translation and copyediting: Alma Reyes
Translation: Kayoko Kimata
Chief Editor and Production Manager: Aki Ueda (ricorico)

Library of Congress Control Number: 2012938432
ISBN: 978-0-06-114990-0
Printed in China
First Printing, 2012

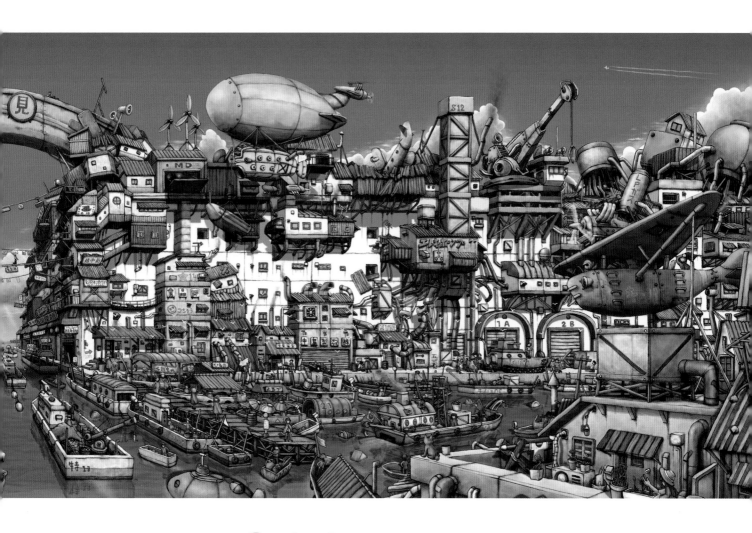

Contents

Foreword

I like objects created by human hands. Certainly, nothing matches nature, which was created by God, but many beautiful things can be created by people. Among the many things that can be created, I am most interested in characters.

What is a character?

After some considerable contemplation, I learned that there are certain rules in the method of creating characters. The design team who created the hugely successful character Ultraman, which has been a tremendous hit in Japan, provided me with the wisdom for character creation. I was told, "Tsukamoto, you cannot design characters one by one. If you are producing a series of characters, you need to design over thirty characters. If you design characters randomly, it will bring out an uncomfortable feeling. You need to have your own 'style.'"

I learned that I needed to have a "style" for creating my characters. The Ultraman design was based upon a sculptural style called "archaic smile," developed during the Archaic period in Greek art. The *Ultraman* series incorporates monster designs, also, which were created by adding elements from various kinds of animals, insects, or monsters taken from Greek mythology under a definite style. This concept is introduced in this book as the Addition method for creating characters.

The Addition method can also be found in Greek mythology: human + horse = centaur, human + bull = minotaur; and so on, wherein two base form elements were combined. From this example, I believe that this method of creating characters appeared in ancient times.

In this book, we shall introduce other techniques for character creation, such as: Subtraction, Division, Multiplication, Using Attributes of Nature, Personification, and the 1-2-3-4-7 Technique. All of these methods explain the concept of the matrix (source of creating life) in developing manga characters. The questions below are ones that you will ask and ones that you will answer.

How do we create characters?

How do we develop charm in characters?

How do we produce a story from characters?

I will be most grateful if my book helps you understand and love characters as much as I do.

Spring 2012
Hiroyoshi Tsukamoto

Super Manga Matrix + - ÷ ×

Introduction

Start here. . .

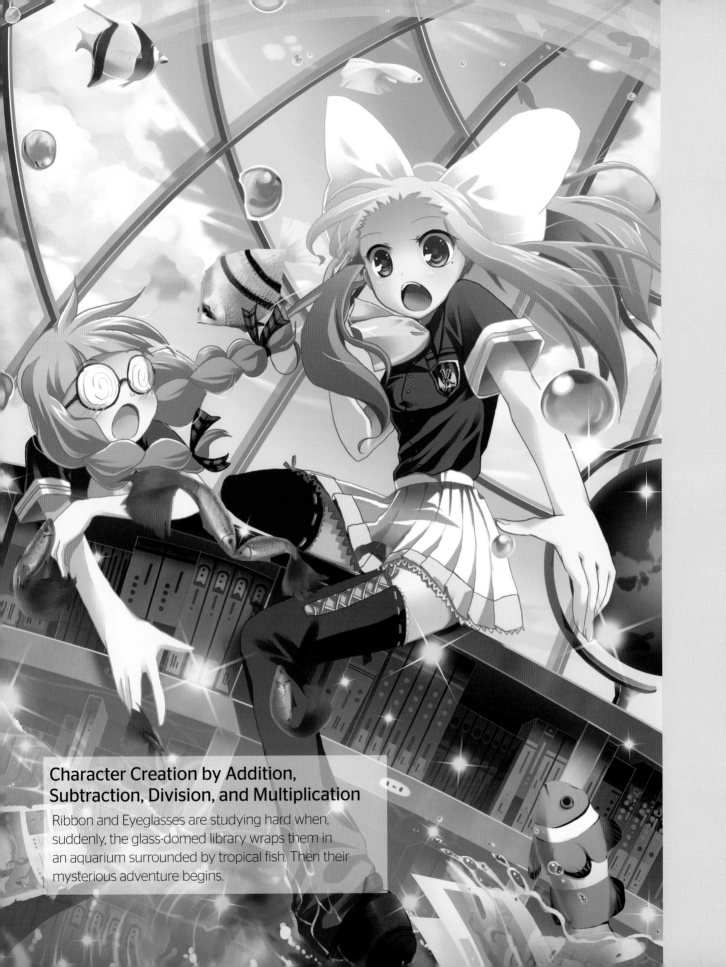

Character Creation by Addition, Subtraction, Division, and Multiplication

Ribbon and Eyeglasses are studying hard when, suddenly, the glass-domed library wraps them in an aquarium surrounded by tropical fish. Then their mysterious adventure begins.

About this book

This book introduces a unique character-creation method using the concepts of Addition, Subtraction, Division, and Multiplication. These concepts are also combined to implement the methods of Using Attributes of Nature, Personification, and the 1-2-3-4-7 Technique. The method of Addition serves as the basic character-creation method, and Multiplication develops a relationship among different characters with individual features in order to create a wide array of dynamic stories.

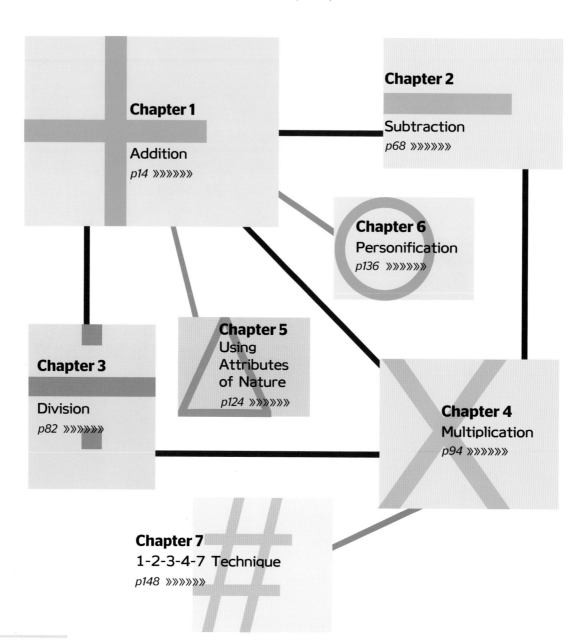

Chapter 1

Addition

p14 »»»»»»

Chapter 2

Subtraction

p68 »»»»»»

Chapter 6
Personification
p136 »»»»»»

Chapter 3

Division

p82 »»»»»»

Chapter 5
Using
Attributes
of Nature
p124 »»»»»»

Chapter 4
Multiplication
p94 »»»»»»

Chapter 7
1-2-3-4-7 Technique
p148 »»»»»»

Chapter 1

Addition
p14

Addition is the basic method for character creation. A costume, particular ornament, personality, ability, tool, and other elements are added to a character to create a new model with distinct characteristics.

p20

p18

p32

p23

Chapter 2

Subtraction
p68

In the Subtraction method, a character is analyzed to identify any unnecessary or unimportant features, which lack an attractive quality. These features are reduced to enhance the more important elements. Consequently, the more attractive features are emphasized to produce a totally unique character.

p74

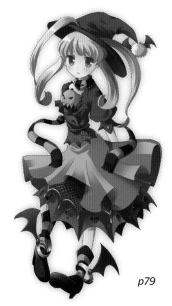

p79

Introduction

A single character may possess different personalities within. Just like Dr. Jekyll and Mr. Hyde, it may sometimes be good and sometimes evil. Multiple personalities can be extracted from the character. This gives it a dramatic appearance.

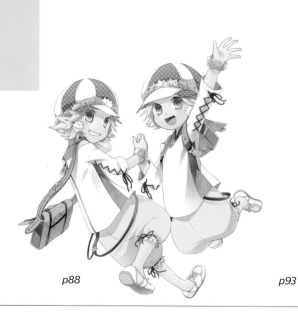

p88

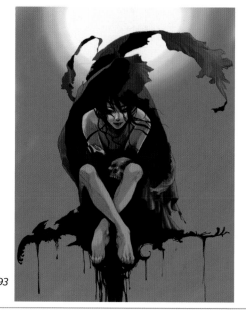

p93

In the Multiplication method, many characters evolve through the combination of Addition, Subtraction, and Division, creating different stories within the main plot. The fusion of characters injects power and drama to the main story, which involves various personalities.

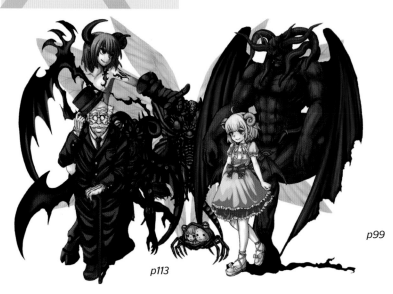

p113

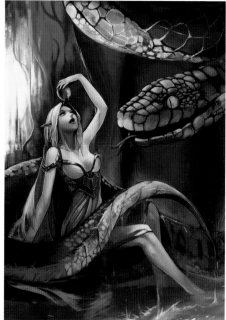

p99

Chapter 5
Using Attributes of Nature
p124 »»»»»»

A character can be further enhanced by using the natural attributes of earth, wind, fire, and water. Adding these elements to the character is one technique in the Addition method.

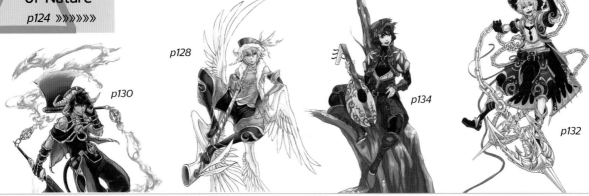

p128

p130

p134

p132

Chapter 6
Personification
p136

The Personification method makes objects and other nonhuman elements such as jewels, flowers, cake, or antique items appear human-like, creating a new character. By infusing the element of love, the characters develop a human quality, which can also be a technique in the Addition method.

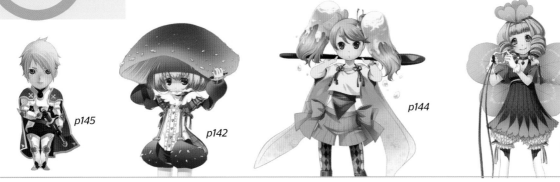

p145

p142

p144

p143

Chapter 7
1-2-3-4-7 Technique
p148

In the 1-2-3-4-7 Technique, several characters appear in the story. A story may focus on one character as the main hero, or two characters with opposing qualities. Another story may have three distinct characters representing the virtues of emotion, action, and knowledge. A story with four characters may use the method for three characters and add the elements of Yin ("Dark" character representing the group leader) or Yang ("Light" character representing the possible leading role in the group). A story with seven or more characters involves different personalities. Having seven characters provides the best balance, charm, and dramatic effect.

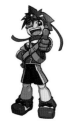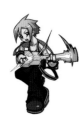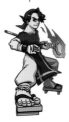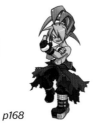

p168

Super Manga Matrix + − ÷ ×

Addition

Chapter 1

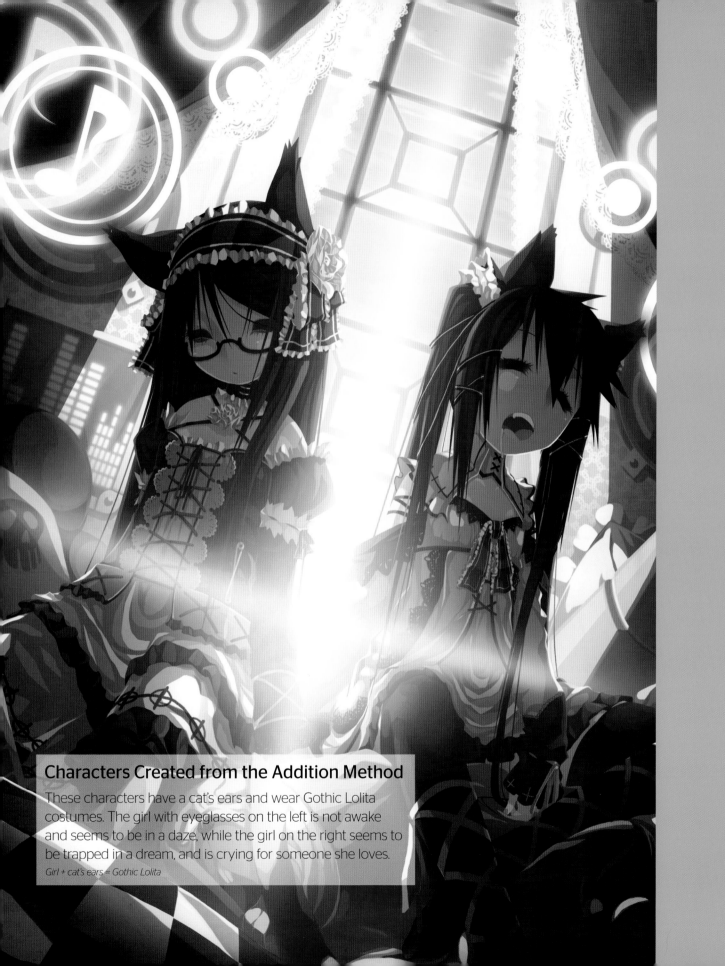

Characters Created from the Addition Method

These characters have a cat's ears and wear Gothic Lolita costumes. The girl with eyeglasses on the left is not awake and seems to be in a daze, while the girl on the right seems to be trapped in a dream, and is crying for someone she loves.

Girl + cat's ears = Gothic Lolita

How to make characters using the Addition method

One or more parts are added to a character's basic structure to create a different character. This character-making technique is referred to as the Addition method, and is the most fundamental technique in character creation.

Some samples of parts that can be added to a character are particular body parts of living creatures, such as a bird's wings and beak, a snake's head, a spider's legs; or nonliving objects, such as a machine part, costumes, kitchen equipment, and others.

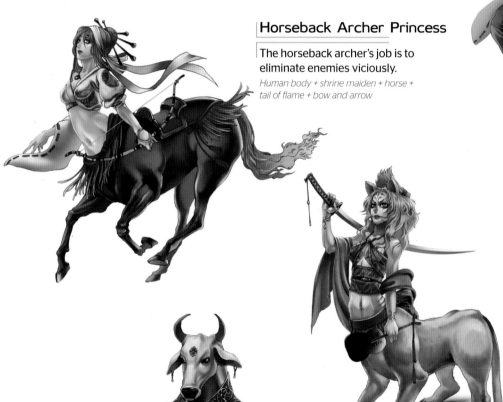

Horseback Archer Princess

The horseback archer's job is to eliminate enemies viciously.

Human body + shrine maiden + horse + tail of flame + bow and arrow

Monster Cat

The Japanese style is manifested in the Imperial clothes, and emphasizes an aristocratic view of the world.

Human + Japanese motif + cat + eight tails

Lion Goddess Warrior

The image shows a fighting goddess. She fights and manipulates enemies by using a gunbai, and cuts the losing enemy's throat with her tachi.

Human body + lion + Kabuki actor's makeup + gunbai (Japanese war fan) + tachi (Japanese sword)

Minotaurus

The head shows a water buffalo motif, and the body is formed into a heavy fighter. Ornaments are adorned on the body to emphasize the skin.

Water buffalo head + human body

Head Variations Using the Addition Method

A character's form can have many variations by just focusing on the head and using the Addition method. By altering the hairstyle, the character can take on various personalities.

 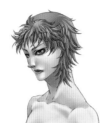 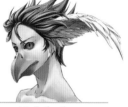

| *Base form* | *Hairstyle 1* | *Hairstyle 2* | *Hairstyle 3* | *Hairstyle 4* |

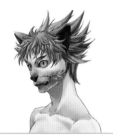 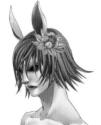 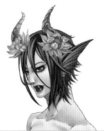 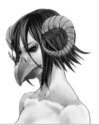 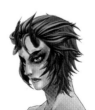

+ lion's eyes, ears, and mouth

+ rabbit's ears
+ rabbit's eyes
+ flower on the head

+ goat's horns
+ snake's mouth
+ dragon's ears
+ flower on the head

+ sheep's horns horns
+ bird's beak

+ bird's feathers on the head
+ bird's mouth
+ cat's eyes

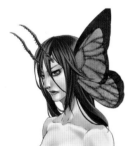 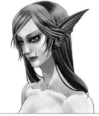 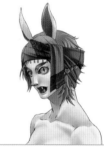

+ antennae
+ butterfly's ears

+ fish fin
+ snake's mouth

+ jewels on the head
+ lion's ears
+ lion's eyes

+ donkey's ears
+ leaves on the head
+ sheep's eyes

+ rabbit's ears
+ reptile's eyes
+ fangs
+ turban

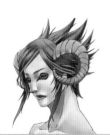 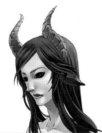 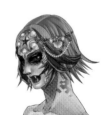 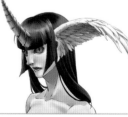

+ sheep's horns
+ sheep's eyes

+ goat's horns
+ goat's ears

+ devil's horns
+ devil's eyes

+ jewels on the head
+ snake's eyes
+ fangs

+ unicorn's horns
+ bird's feathers on the head

Chapter 1

nekomimi

猫耳

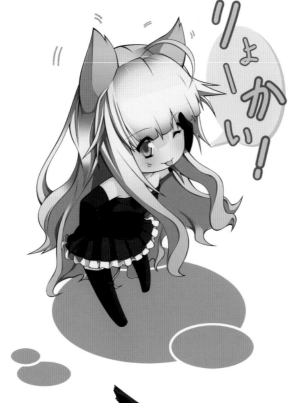

Girl + Cat's Ears

The cat has always been an attractive subject for many illustrators. Cleopatra's facial makeup was modeled after a cat. Cats attract people not just by the way they look, but also by the way they sit, walk, and behave like humans. The cat's eyes display different expressions when she wants to be spoiled, or when she tries to act indifferently, and these features make this cute animal utterly charming.

Girl + cat's ears

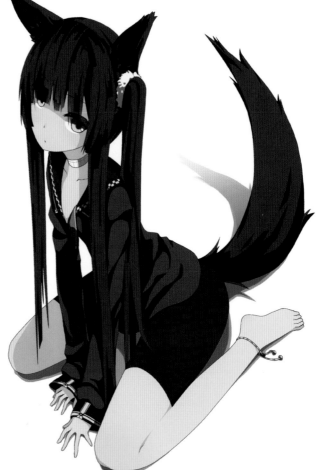

Black Catgirl

By adding the form of the cat to the girl, the character becomes more interesting.

Girl + cat's ears + tail

Fox Incarnation

The image of a fox with a split tail that reincarnates into a powerful fairy is based on a popular Japanese tale. The split tail, cat's ears, large sword, and the Japanese motif of a ninja costume are added to this character to represent the image of justice and trust.

Girl + cat's ears + two-layered tail + ninja costume

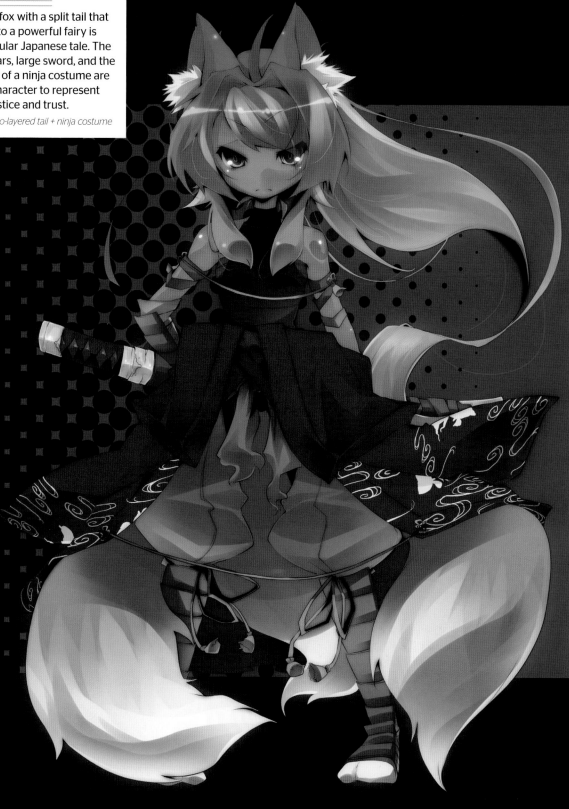

animal people

獣人

Girl with Dragon Power

The dragon's features are added to the lower body of the girl. The girl's power comes not only from the dragon, but also from her ability to reason and to feel.

Girl + half-dragon body

Girl with Tiger Power

The tiger possesses both a physical beauty and incredible power comparable to the strength of the one hundred beasts that fought the Lion King. By adding the tiger's ears, tail, and skin pattern to the girl's appearance, a contrast of strength and weakness is created, making this a very attractive character.

Girl + tiger's ears + tiger's tail + tiger-motif costume

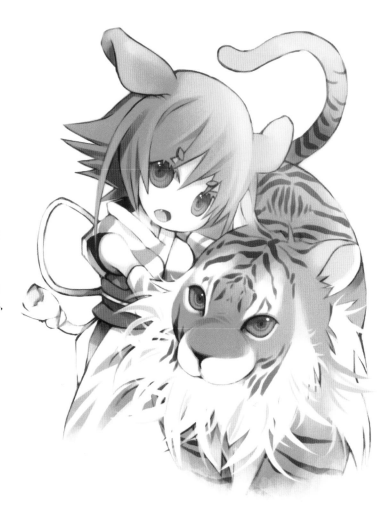

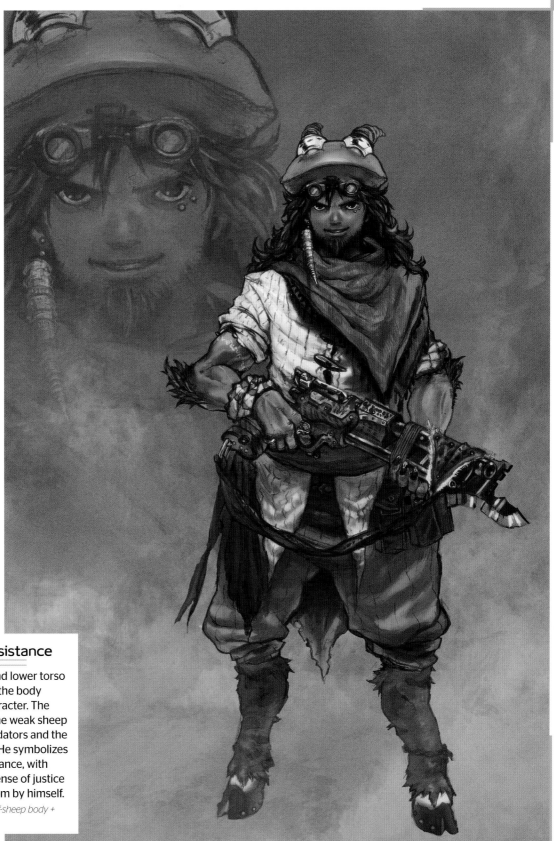

Shepherd's Resistance

The sheep's horns and lower torso have been added to the body of this shepherd character. The shepherd protects the weak sheep from dangerous predators and the harsh environment. He symbolizes the element of resistance, with compassion and a sense of justice of fighting for freedom by himself.

Man + sheep's horns + half-sheep body + weapon

winged characters

翼人

Crow Maiden and Young Fox

The crow maiden and the young fox come from two separate families: and fall into forbidden love, as depicted by the opposing directions of their angles. Their union is manifested by the crow maiden's hand on the leg of the young fox.

Youth + fox's ears + split tail + Japanese costume;
Maiden + crow's wings + Japanese costume

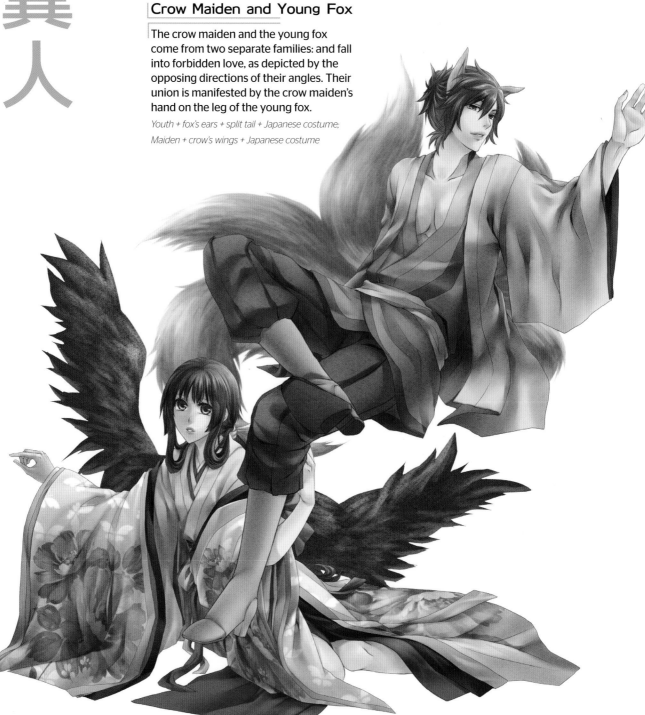

Phoenix Maiden

An image of a phoenix and a firebird are added to this phoenix maiden character. Dressed in Japanese attire, she takes sides with the good and strikes the evil with fire and her bow and arrow.

Maiden + immortal bird + Japanese costume + bow and arrow

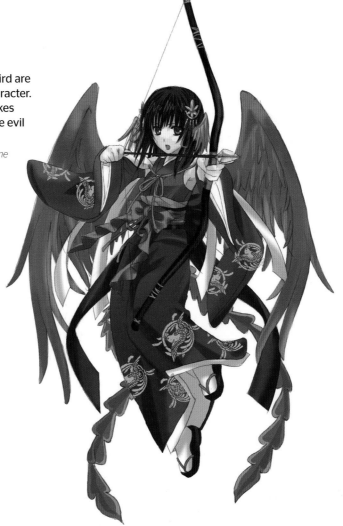

Batgirl

This batgirl has to live alone for a long time due to her cursed destiny. She suffers from despair, and drifts away like a dead person.

Girl + bat's wings

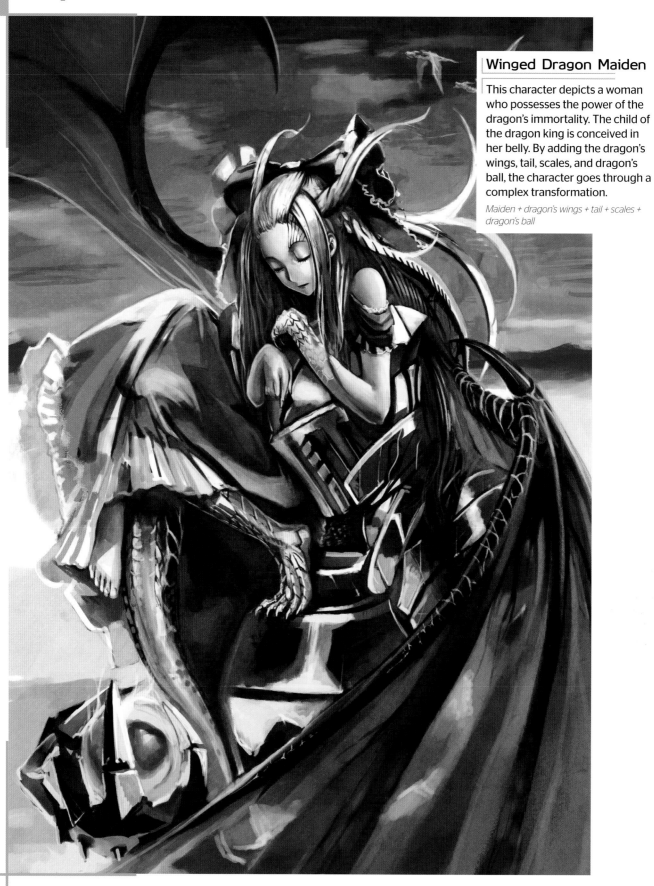

Winged Dragon Maiden

This character depicts a woman who possesses the power of the dragon's immortality. The child of the dragon king is conceived in her belly. By adding the dragon's wings, tail, scales, and dragon's ball, the character goes through a complex transformation.

Maiden + dragon's wings + tail + scales + dragon's ball

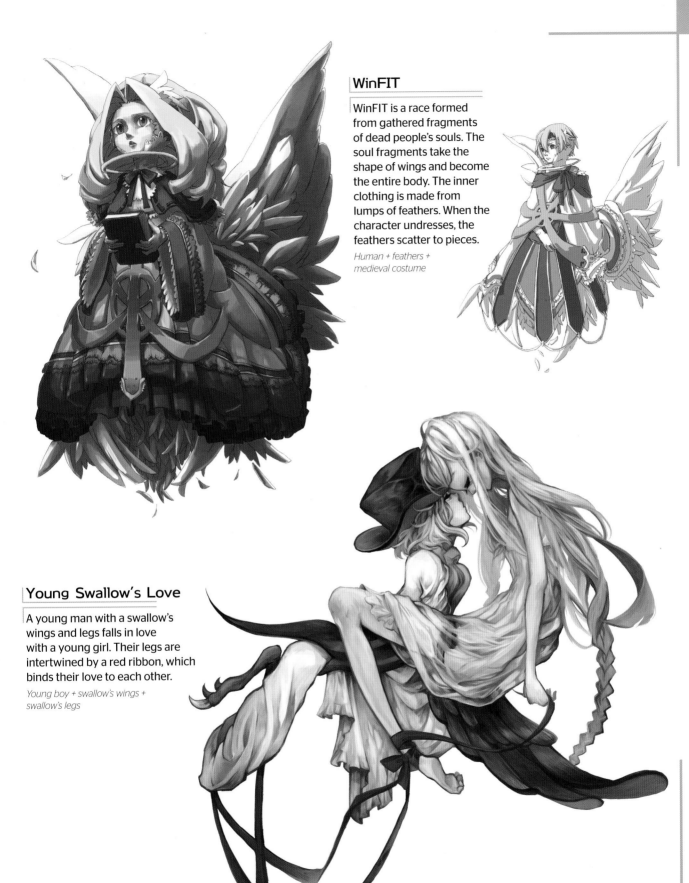

WinFIT

WinFIT is a race formed from gathered fragments of dead people's souls. The soul fragments take the shape of wings and become the entire body. The inner clothing is made from lumps of feathers. When the character undresses, the feathers scatter to pieces.

Human + feathers + medieval costume

Young Swallow's Love

A young man with a swallow's wings and legs falls in love with a young girl. Their legs are intertwined by a red ribbon, which binds their love to each other.

Young boy + swallow's wings + swallow's legs

insect people

虫人

Spider Witch

This spider witch is a combination of a spider, mask, cane, and an old woman. She is cautious and possesses deep knowledge.

Witch + spider + cane + mask

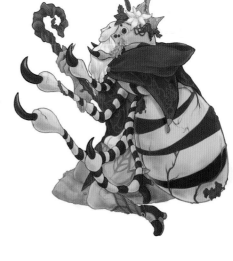

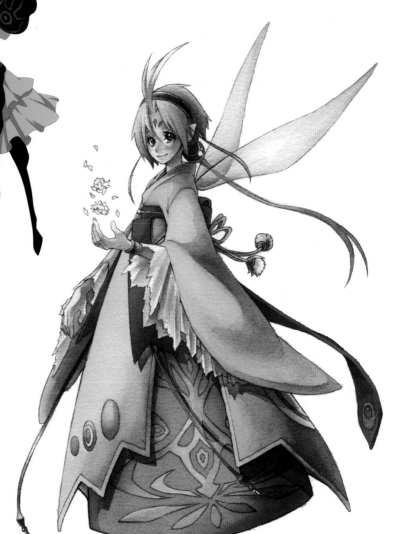

Butterfly Maiden

The butterfly is one of the most beautiful creatures in the insect world. It may be slightly evil but projects its radiant beauty.

Maiden + butterfly

Mayfly Princess

The mayfly has a short lifespan. The character design is based on a fairy's transitory beauty.

Princess + mayfly + Japanese costume

fish people

魚人

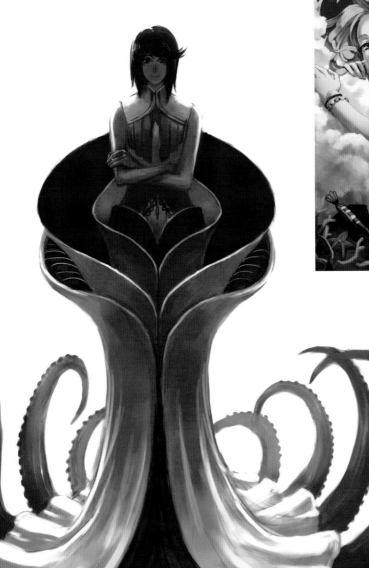

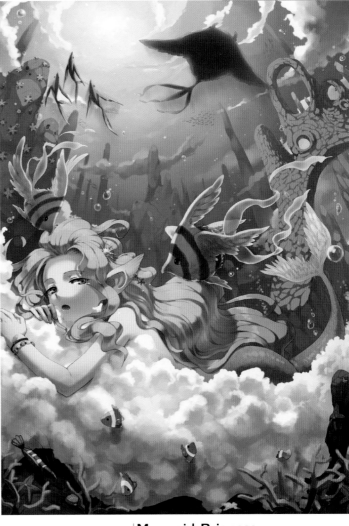

Mermaid Princess

The mermaid is a human fish, and is a typical character that uses the Addition method. Her heartrending look and complicated expression comes from her virgin experience of love.

Princess + half-fish body

Female Squid

This character combines the legs of both the octopus and the squid. It takes the form of a woman with a strange and dreadful appearance.

Woman + squid's legs

horned characters

角人

Maiden Devil

The horn is proof of growth and a symbol of power. The maiden was born as a devil without her knowledge. Her horns grew as she grew up, giving her tribe further strength and deep sorrow. People who hear the bells tied around her ankle are reminded of their existence.

Maiden + devil's horns + Japanese costume + bells

Yaoyorozu no kami (Eight Million Gods)

In Japan, it is believed that due to its geographical terrain and the rich blessings of every season, gods live everywhere—in flowers, rocks, trees, and houses—and that their figures are formed by adding elements, such as a horn, mask, beast's ears, or a tail. The mothers and child in this illustration extract blood from the gods, and become protectors of the cow, deer, and fox, as they continue their journey to rebuke men's foolish deeds.

Maiden + cow's horns + Japanese costume
Girl + deer's horns + fox mask + Japanese costume
Boy + fox's ears + fox's tail + Japanese costume

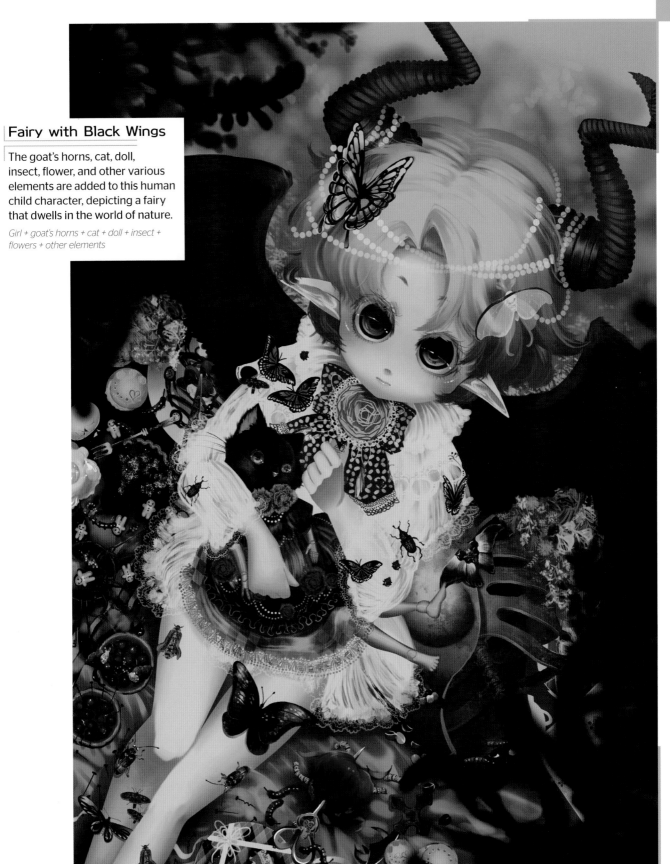

Fairy with Black Wings

The goat's horns, cat, doll, insect, flower, and other various elements are added to this human child character, depicting a fairy that dwells in the world of nature.

Girl + goat's horns + cat + doll + insect + flowers + other elements

character transformation through costume variation

Girl Character

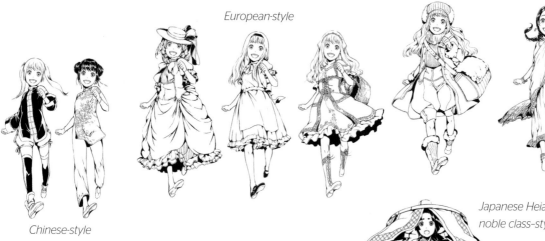

night wear

school uniform

girl's base form

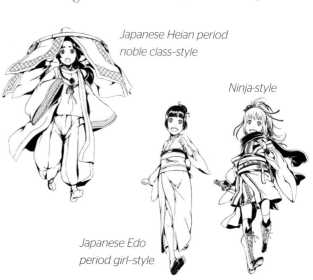

European-style

Russian-style

Indian-style

Chinese-style

Japanese Heian period noble class–style

Native American–style

Female thief

Ninja-style

Japanese Edo period girl–style

Adding Various Costumes

A character's image can change completely by just varying its costume.
Adding costumes to a character is an important technique in the Addition method.

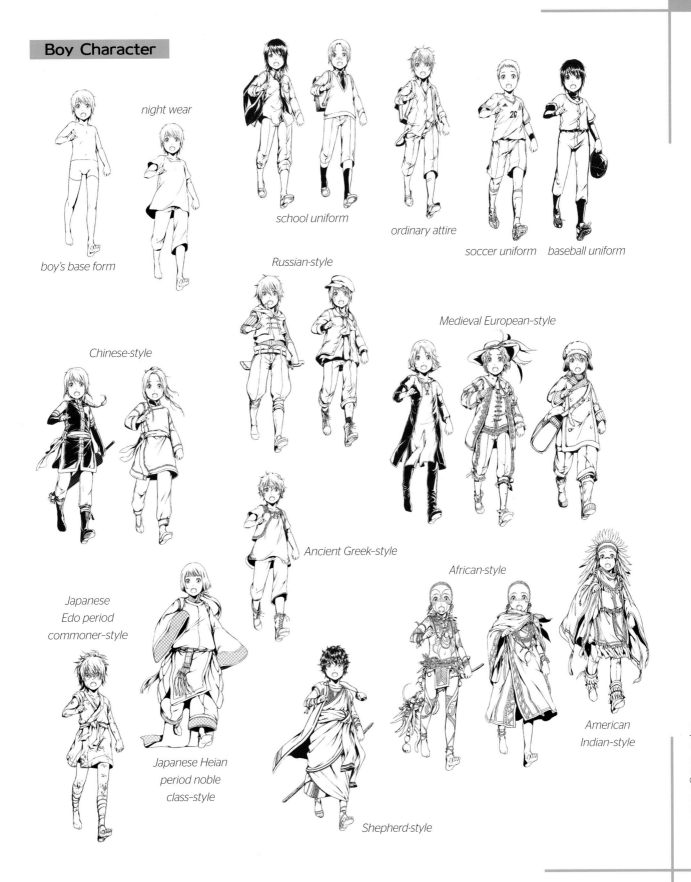

Boy Character

night wear

boy's base form

school uniform

ordinary attire

soccer uniform

baseball uniform

Russian-style

Chinese-style

Medieval European-style

Ancient Greek-style

African-style

Japanese
Edo period
commoner–style

American
Indian-style

Japanese Heian
period noble
class–style

Shepherd-style

fashion queue

美飾

Fashionable Women
Even an ordinary-looking character without any particular individuality can momentarily become refreshingly attractive by just adding an original costume.

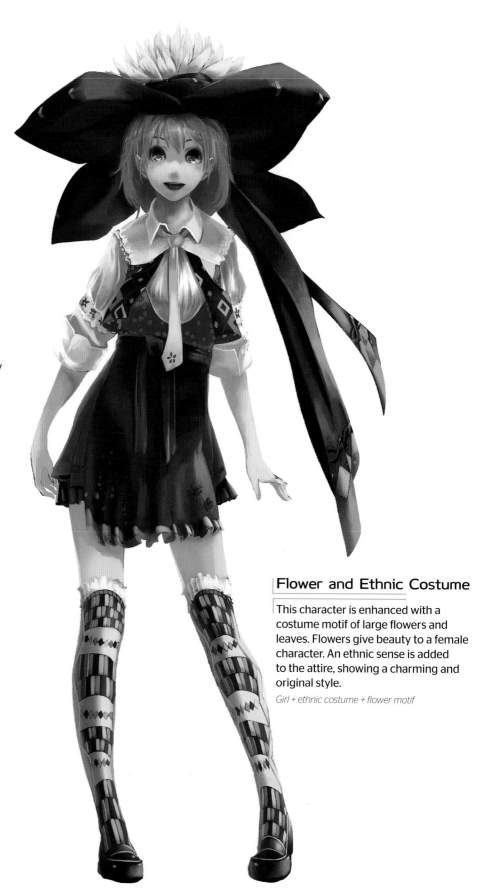

Flower and Ethnic Costume

This character is enhanced with a costume motif of large flowers and leaves. Flowers give beauty to a female character. An ethnic sense is added to the attire, showing a charming and original style.

Girl + ethnic costume + flower motif

Warrior Queen's Mourning Attire

It is the fate of this sad queen to fight. By using black as the base color of her mourning dress, the queen shows her destiny to kill. Yet, the white lilies that surround her represent the cleanliness of her heart.

Queen + black dress + white lilies

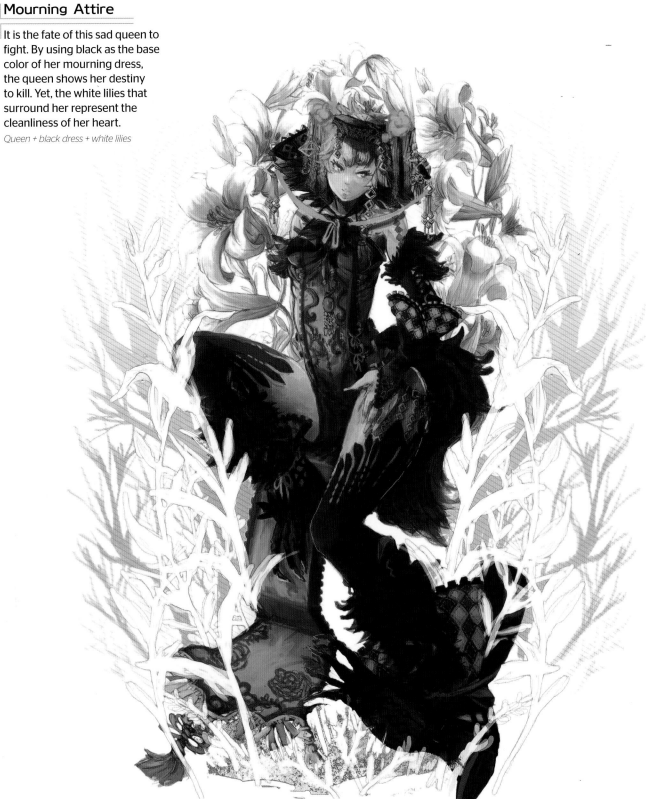

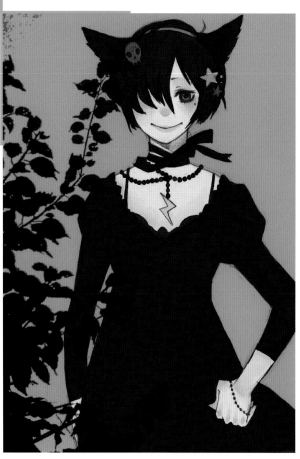

Black Cat Girl

This character has a young and girlish appearance. The cat's ears and black dress give her a black cat image.

Girl + cat ear-shaped hairband + black dress

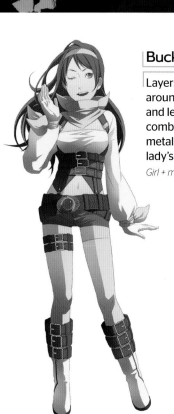

Buckle Lady

Layers of belts are wrapped around the character's waist and legs, highlighted by a combination of leather and metal that emphasizes the lady's soft skin.

Girl + metal and leather belts

American Woman

The costume is inspired by the colors and motif of the American flag, and exudes brightness and strength.

Woman + battle costume + American flag design

Mini Cat Girl

The cat girl looks like a perfectly charming pink kitten doll. The hat is accentuated by cats' favorite fish motif.

Girl + pink color + cat-motif hat + fish ornaments + cat-motif buckle

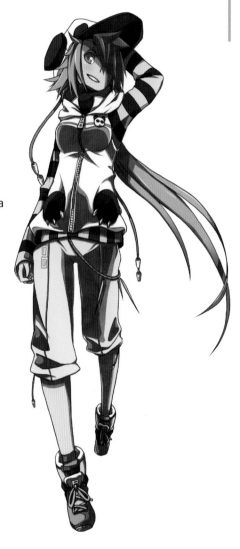

Panda Girl

The costume is based on a panda motif, accentuated by the hat, the badge pin on the breast, and the pockets, showing a very nonchalant panda image.

Girl + panda-motif hat + panda-motif brooch + panda-motif pockets

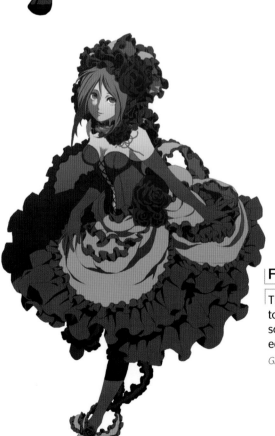

Flower Lady

This lovely dress seems to be a huge flower with soft ruffles and petal-motif edges around the skirt.

Girl + flower-motif dress

character transformation through variations in features

Girl Character

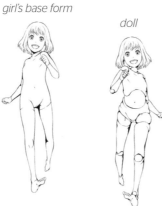

girl's base form

doll

bandage

dragon

scales

cat's ears

water

stitch eyes

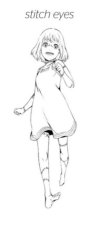

mermaid

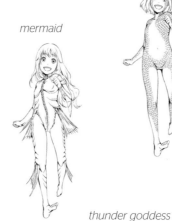

baby-like feature

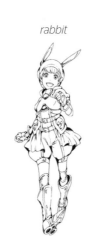

rabbit

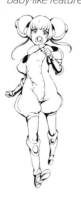

thunder goddess

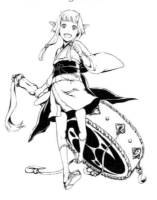

fairy

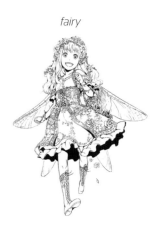

Adding Various Features

A character's image can easily be transformed by adding different elements, abilities or special features to it. This is an important technique in the Addition method.

Boy Character

boy's base form

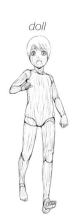

doll

bandage

tattoo

stones

stitch eyes

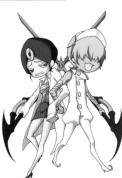

cat's ears

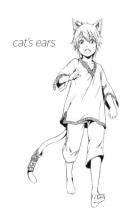

tiger

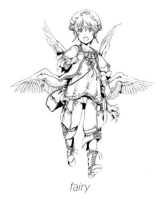

fairy

Sample Characters

The axes show a gap in the doctor's and nurse's image as healers, and at the same time, as fighters.

Doctor + axe
Nurse + axe

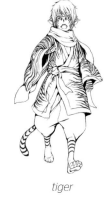

The maid's uniform gives the robot a different aura.

Robot + maid

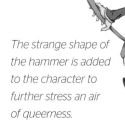

The strange shape of the hammer is added to the character to further stress an air of queerness.

Boy + strangely shaped hammer

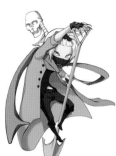

A mask, shovel, and skeletal appearance create the image of a grave robber.

Man + mask + shovel + skeleton

The peculiar house steward bows in his strange attire.

House steward + deformed long-tail suit

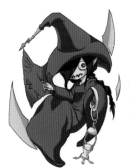

The lamp gives a more eerie feeling to this witch.

Witch + lamp

Chapter 1

armed characters

武器人

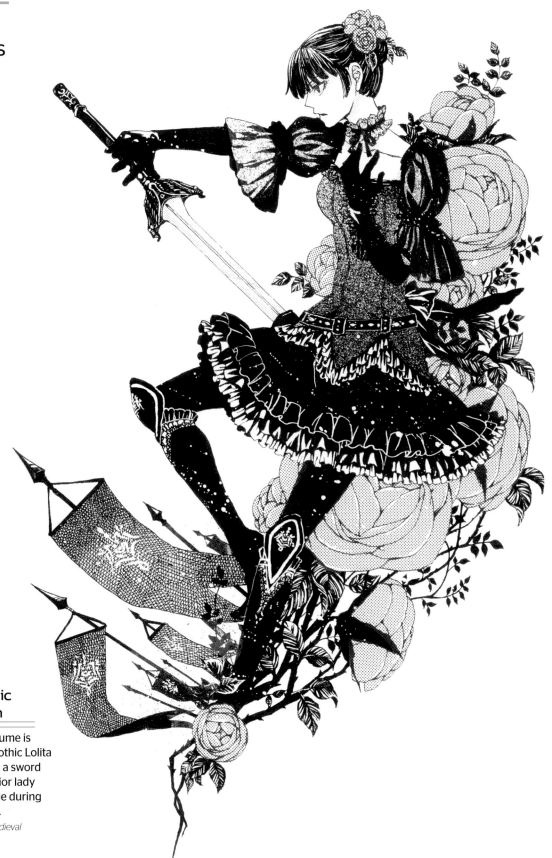

Beautiful Magic Swordswoman

The mourning costume is fashioned after a Gothic Lolita style. Adorned with a sword and roses, the warrior lady seems to be in battle during the medieval times.

Girl + magic sword + medieval costume + roses

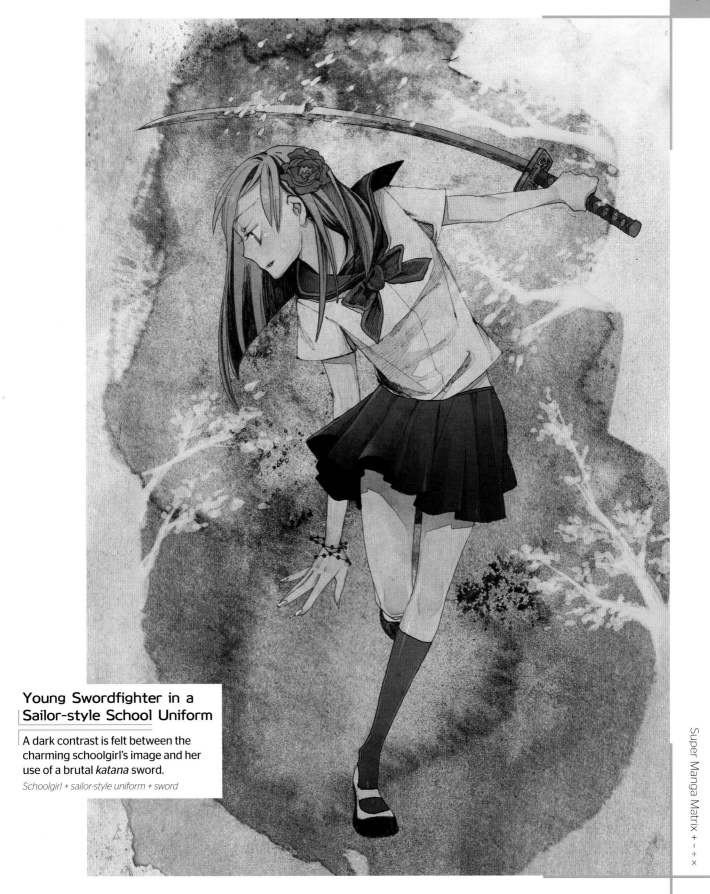

Young Swordfighter in a Sailor-style School Uniform

A dark contrast is felt between the charming schoolgirl's image and her use of a brutal *katana* sword.

Schoolgirl + sailor-style uniform + sword

Black Soldier

The medieval armor suit
is mixed with a present-
day miniskirt. Revealing
the character's skin
slightly emphasizes a
feminine touch.

*Woman + medieval armor +
miniskirt + sword*

Genie and the
Clock Tower

This dark, young girl has burning
red hair and holds powerful
weapons in her hands. The
weapons are futuristic, but the
background and girl's costume
are Gothic-styled, giving the
picture a nostalgic ambience.

*Girl + red hair + powerful weapon +
Gothic-style building*

Female Soldier
with Goat's Horns

Goat's horns, bird's legs, and
an ethnic costume are added
to this character. Her soft
skin contrasts with the cruel
power of her long sword.

*Woman + goat's horns + bird's legs +
ethnic costume + long sword*

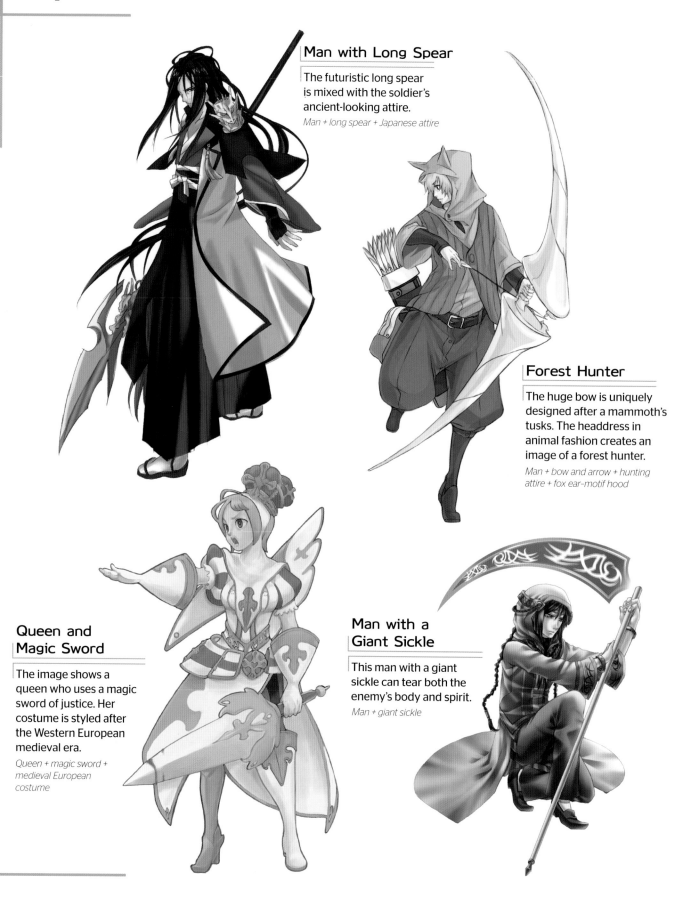

Man with Long Spear

The futuristic long spear is mixed with the soldier's ancient-looking attire.

Man + long spear + Japanese attire

Forest Hunter

The huge bow is uniquely designed after a mammoth's tusks. The headdress in animal fashion creates an image of a forest hunter.

Man + bow and arrow + hunting attire + fox ear-motif hood

Queen and Magic Sword

The image shows a queen who uses a magic sword of justice. Her costume is styled after the Western European medieval era.

Queen + magic sword + medieval European costume

Man with a Giant Sickle

This man with a giant sickle can tear both the enemy's body and spirit.

Man + giant sickle

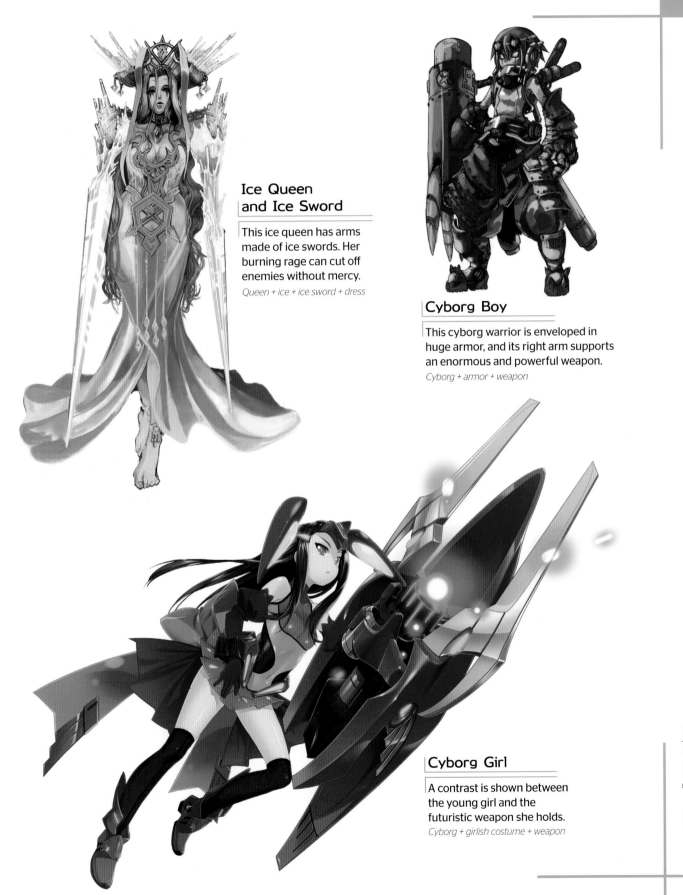

Ice Queen and Ice Sword

This ice queen has arms made of ice swords. Her burning rage can cut off enemies without mercy.

Queen + ice + ice sword + dress

Cyborg Boy

This cyborg warrior is enveloped in huge armor, and its right arm supports an enormous and powerful weapon.

Cyborg + armor + weapon

Cyborg Girl

A contrast is shown between the young girl and the futuristic weapon she holds.

Cyborg + girlish costume + weapon

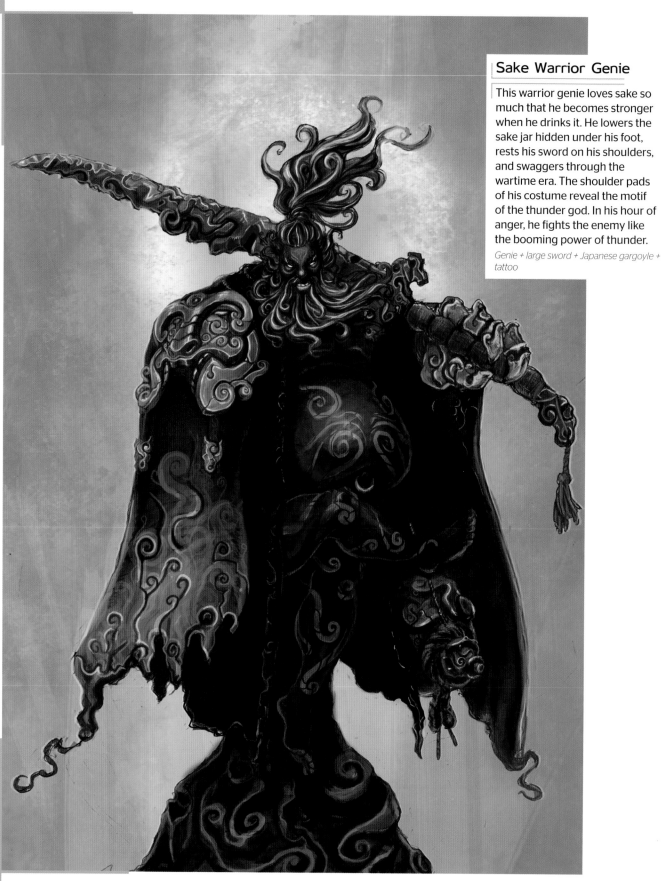

Sake Warrior Genie

This warrior genie loves sake so much that he becomes stronger when he drinks it. He lowers the sake jar hidden under his foot, rests his sword on his shoulders, and swaggers through the wartime era. The shoulder pads of his costume reveal the motif of the thunder god. In his hour of anger, he fights the enemy like the booming power of thunder.

Genie + large sword + Japanese gargoyle + tattoo

Machine Witch

This witch is made of steel and carries a weapon shaped like a vacuum cleaner. Her body is composed of various machine parts that transform her into a powerful machine being.

Witch + robot + vacuum cleaner + other machines

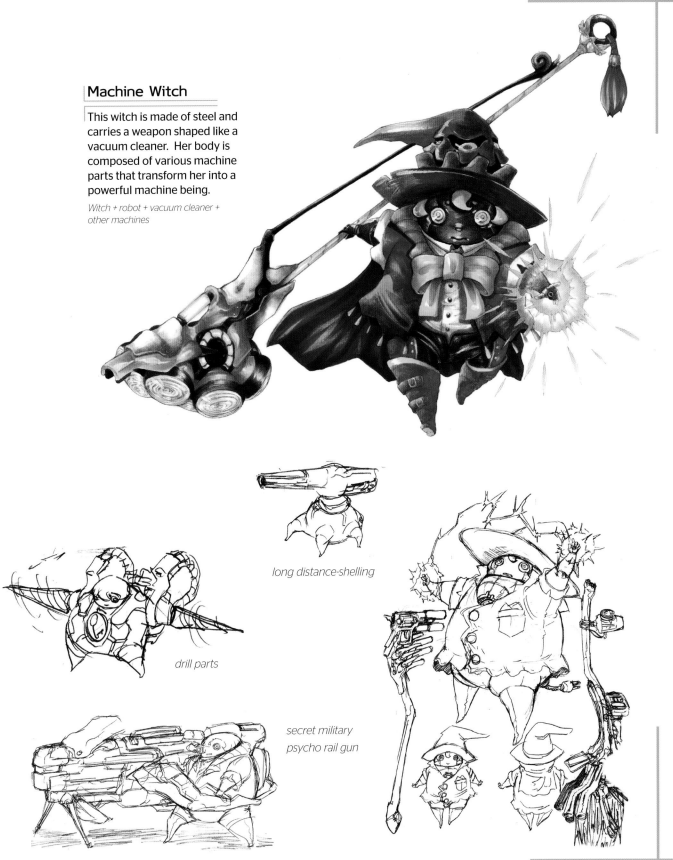

long distance-shelling

drill parts

secret military psycho rail gun

Destiny of the Armor Lady

This armor has sharp nails that eat through lustrous skin, and it synthesizes with anyone who wears it. It has the power to extract the person's hidden potential and multiply their strength a hundredfold. Then, it exchanges itself for the person's life. The breast plate is made from a crab's shell, and the claws under the breast plate come from a crab's legs.

Woman + sharp nails + armor + crab

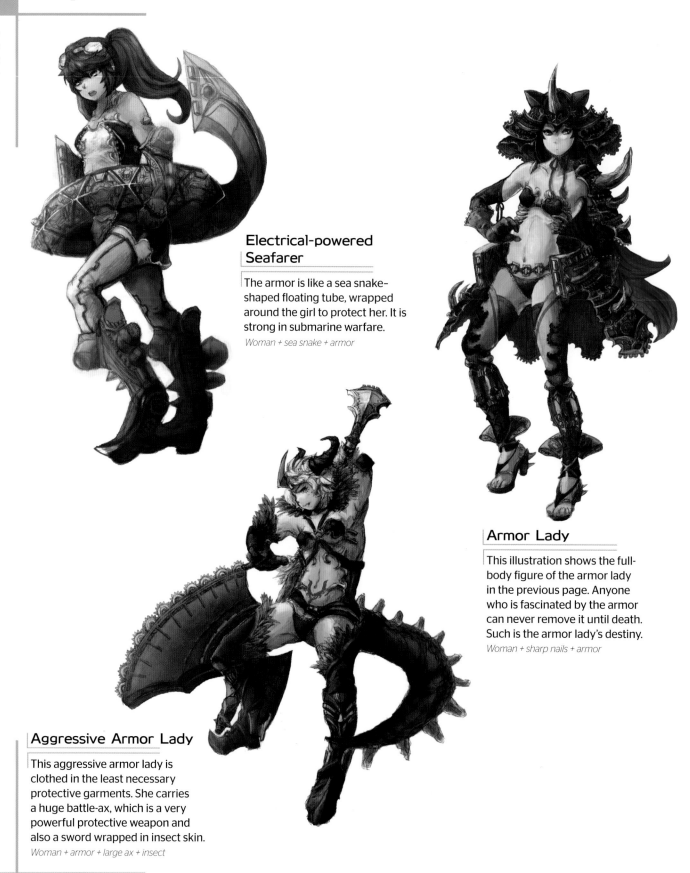

Electrical-powered Seafarer

The armor is like a sea snake-shaped floating tube, wrapped around the girl to protect her. It is strong in submarine warfare.

Woman + sea snake + armor

Armor Lady

This illustration shows the full-body figure of the armor lady in the previous page. Anyone who is fascinated by the armor can never remove it until death. Such is the armor lady's destiny.

Woman + sharp nails + armor

Aggressive Armor Lady

This aggressive armor lady is clothed in the least necessary protective garments. She carries a huge battle-ax, which is a very powerful protective weapon and also a sword wrapped in insect skin.

Woman + armor + large ax + insect

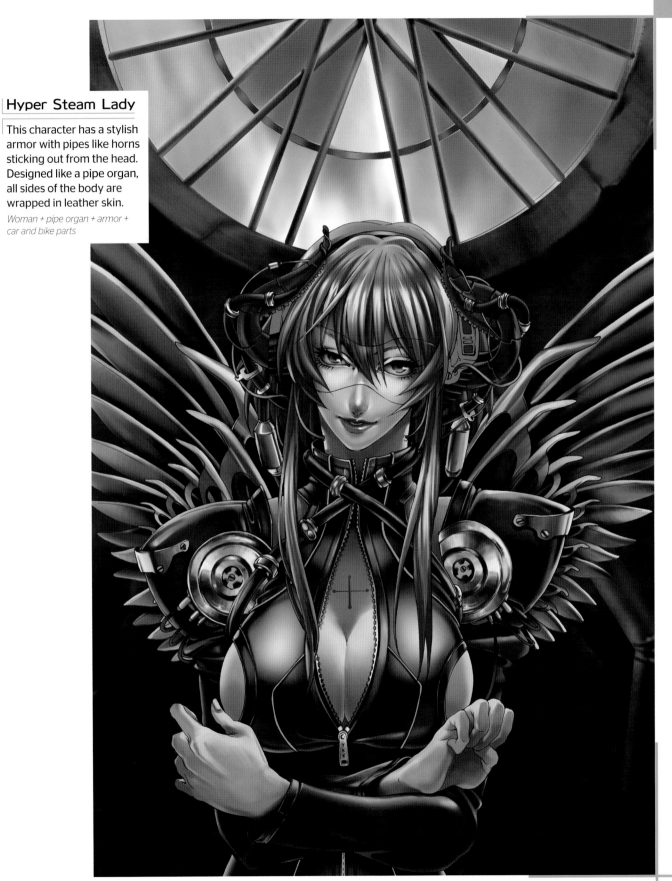

Hyper Steam Lady

This character has a stylish armor with pipes like horns sticking out from the head. Designed like a pipe organ, all sides of the body are wrapped in leather skin.

Woman + pipe organ + armor + car and bike parts

Chapter 1

giant dragon

Giant Dragon

The dragon delivers messages from the ancient world, and is one of the most auspicious creatures in nature. It is gentle, but proud and violent, and does not coexist peacefully with man.

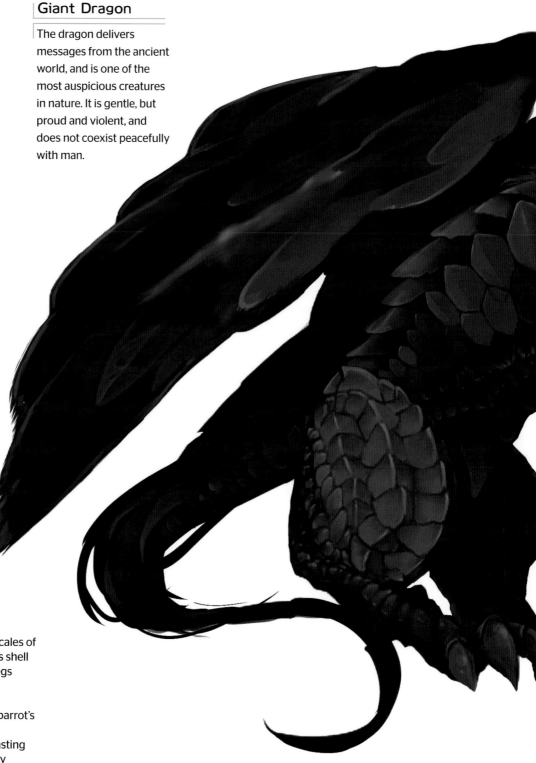

Body: Giant lizard
Scales: Strong and tough scales of a crab, shrimp, and a turtle's shell
Legs: Dinosaur-like bird's legs
Eyes: Attractive cat's eyes
Wings: Crow's black wings
Head: Small, resembling a parrot's head, with a cockscomb
Tail: Horse's soft tail, contrasting the tough scales of the body

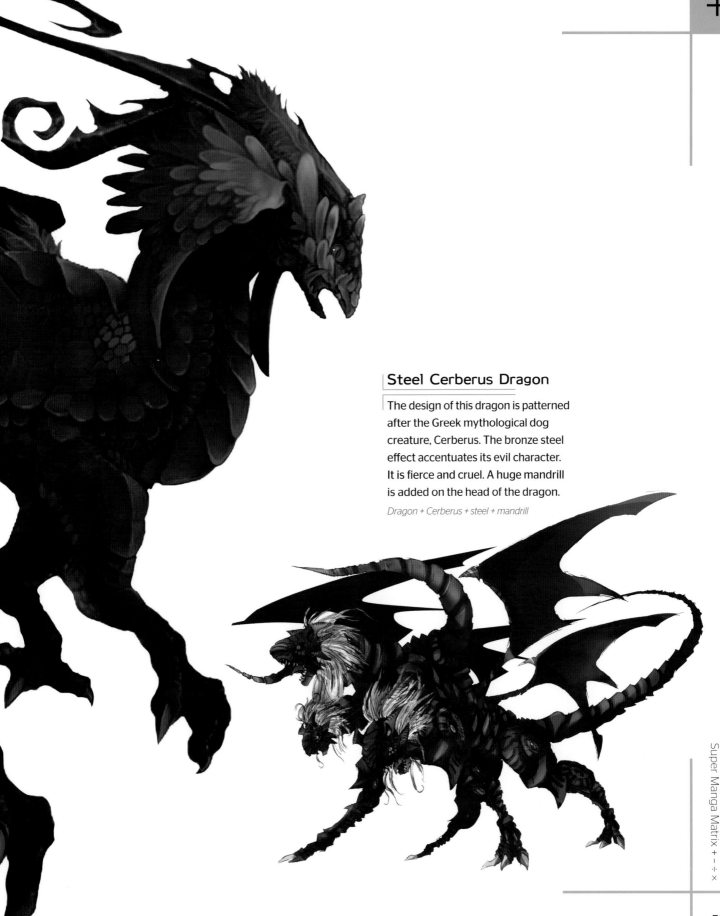

Steel Cerberus Dragon

The design of this dragon is patterned after the Greek mythological dog creature, Cerberus. The bronze steel effect accentuates its evil character. It is fierce and cruel. A huge mandrill is added on the head of the dragon.

Dragon + Cerberus + steel + mandrill

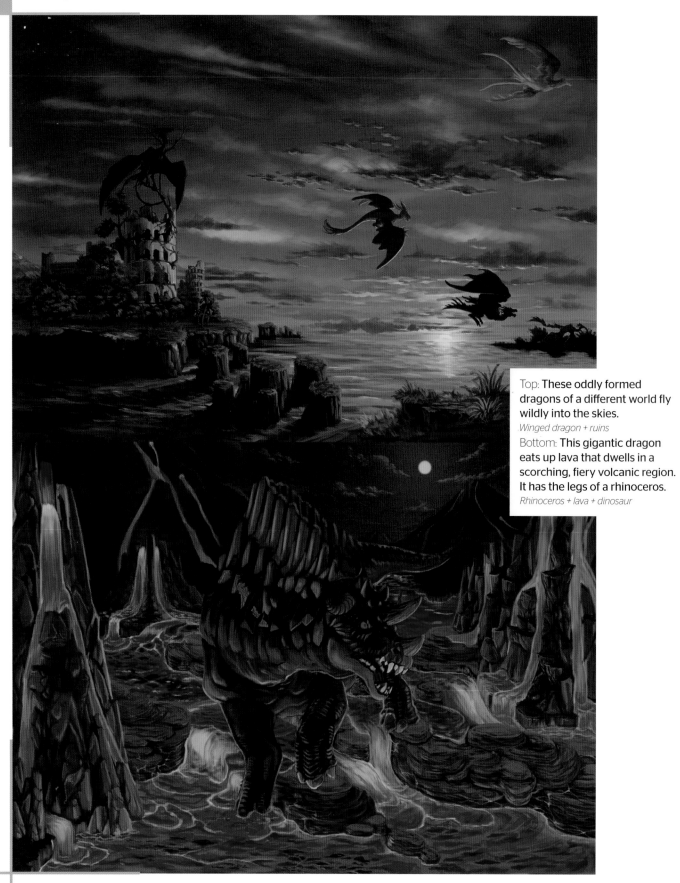

Top: **These oddly formed dragons of a different world fly wildly into the skies.**
Winged dragon + ruins

Bottom: **This gigantic dragon eats up lava that dwells in a scorching, fiery volcanic region. It has the legs of a rhinoceros.**
Rhinoceros + lava + dinosaur

Dragons of a Different World

These dragons have evolved in time beyond man's imagination. Their figures were formed from the severe environment of the different world where they live.

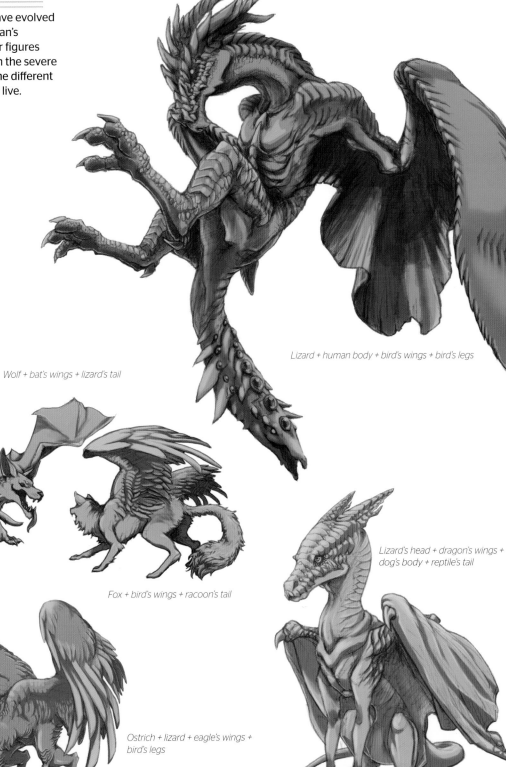

Lizard + human body + bird's wings + bird's legs

Wolf + bat's wings + lizard's tail

Fox + bird's wings + racoon's tail

Lizard's head + dragon's wings + dog's body + reptile's tail

Ostrich + lizard + eagle's wings + bird's legs

monsters of nature

自然ノ怪

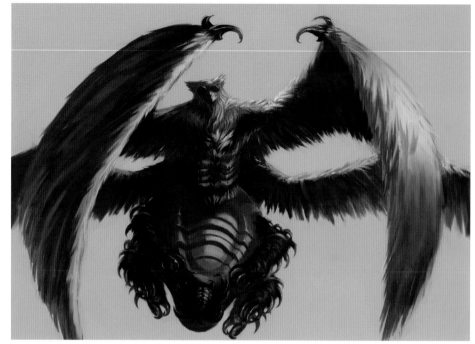

Owl Monster

This outrageous monster has the body form of an owl, has four wings, and was born from an anthropoid.

Owl + four wings + legs + anthropoid's lower torso

Crab Monster

This monster with the body of a crab and a human head comes from the crustacean species. The shape of its rounded legs and claws is based on a car's tire and steering wheel.

Human face + crab + tire and steering wheel

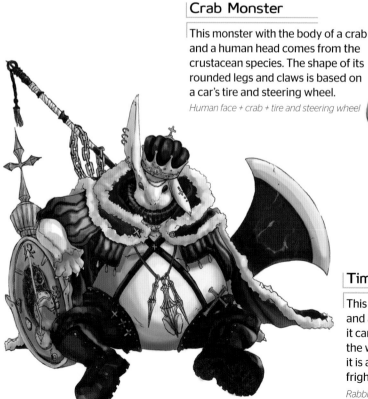

Time Rabbit

This rabbit creature wears boots and a king's crown and cape. Also, it carries a huge ax. It rules over the world of rabbits. Generally, it is a gentleman, but can be frightening when enraged.

Rabbit + clock + large axe + king's crown + cape + boots

Mineral Monster

With a body that appears to be made of clay, this monster is a unique mixture of minerals and a tree.

Minerals + tree

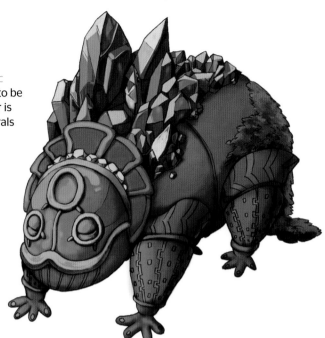

Bonfire Monster

Made of fallen leaves and firewood around the mouth, this monster possesses both kindness and the power to reproduce other monsters.

Fallen leaves + firewood + cape + owl

Seashell Monster

This monster is made from seashells and corals.

Conch shell + corals

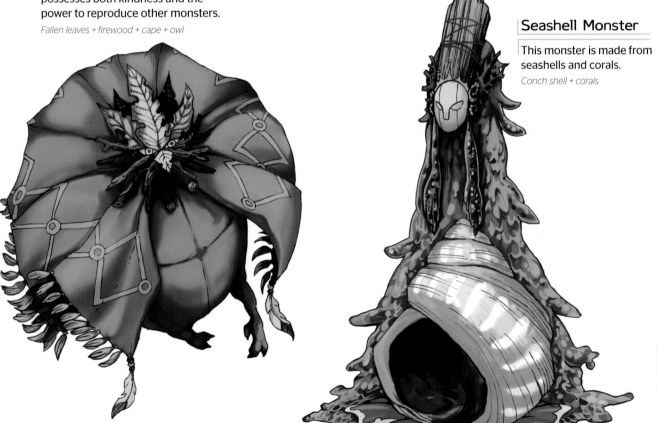

Addition

tool and instrument monsters

These monsters combine the forms of familiar tools and insects.

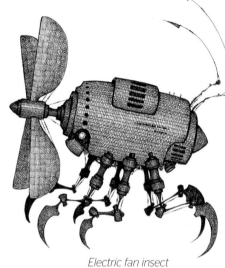

Electric fan insect
Insect + electric fan

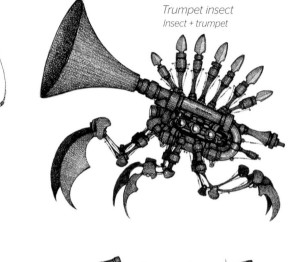

Trumpet insect
Insect + trumpet

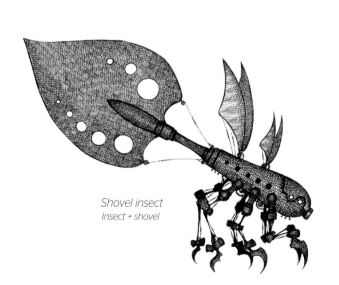

Telescope insect
Insect + telescope

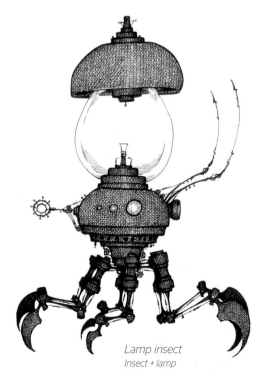

Lamp insect
Insect + lamp

Shovel insect
Insect + shovel

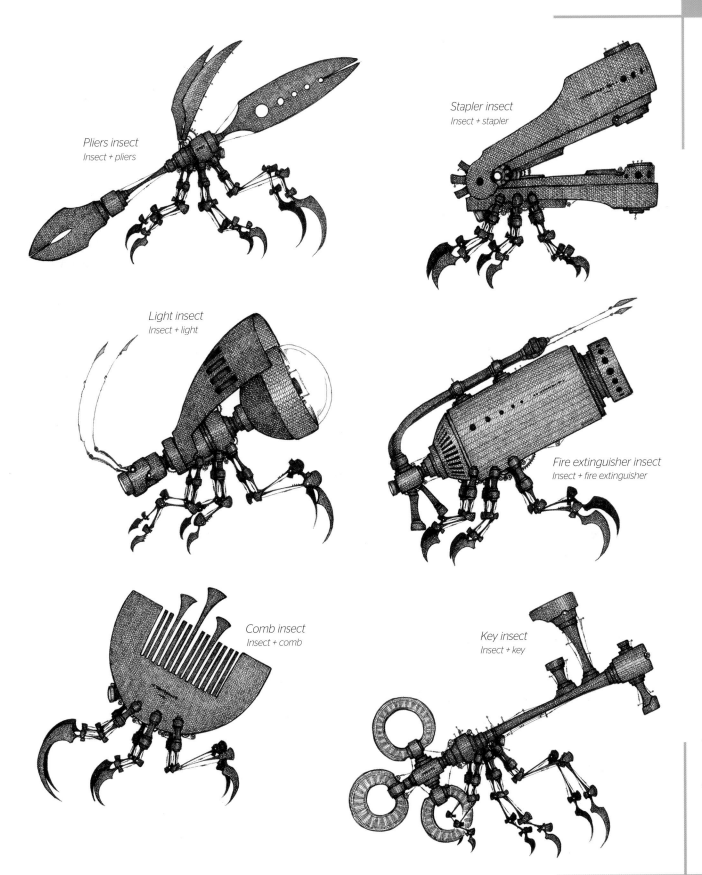

Pliers insect
Insect + pliers

Stapler insect
Insect + stapler

Light insect
Insect + light

Fire extinguisher insect
Insect + fire extinguisher

Comb insect
Insect + comb

Key insect
Insect + key

gigantic robots

巨大ロボ

Giant Battle God Machine

This giant robot is a combination of a high-energy machine and an unbreakable meteorite. On its shoulders rests a very powerful propeller, which is a highly deadly weapon for killing enemies.

Giant + robot + shell + giant engine

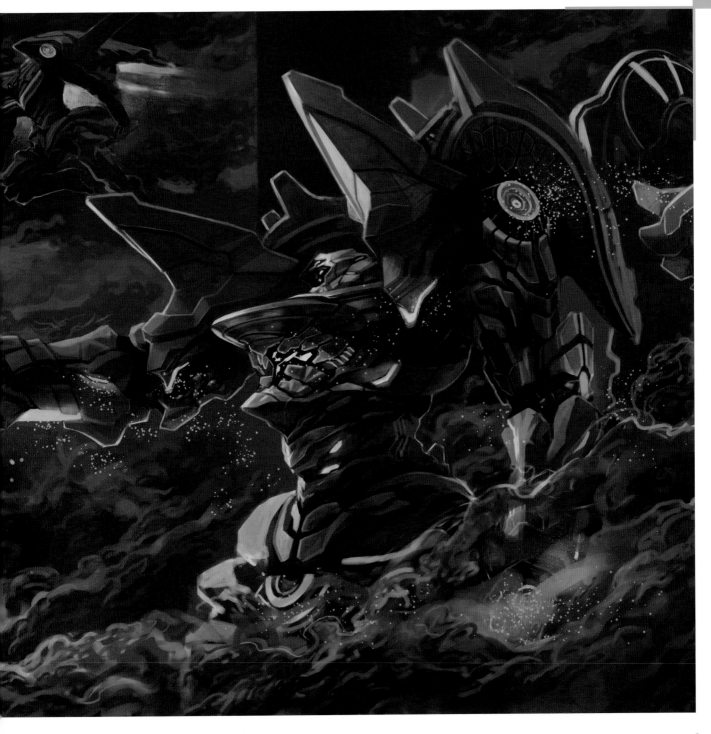

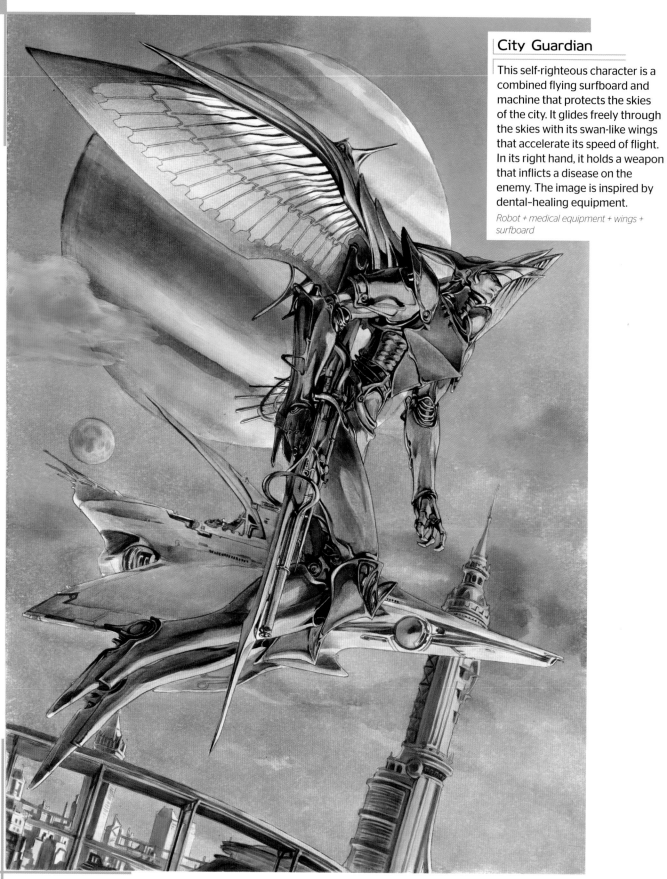

City Guardian

This self-righteous character is a combined flying surfboard and machine that protects the skies of the city. It glides freely through the skies with its swan-like wings that accelerate its speed of flight. In its right hand, it holds a weapon that inflicts a disease on the enemy. The image is inspired by dental–healing equipment.

Robot + medical equipment + wings + surfboard

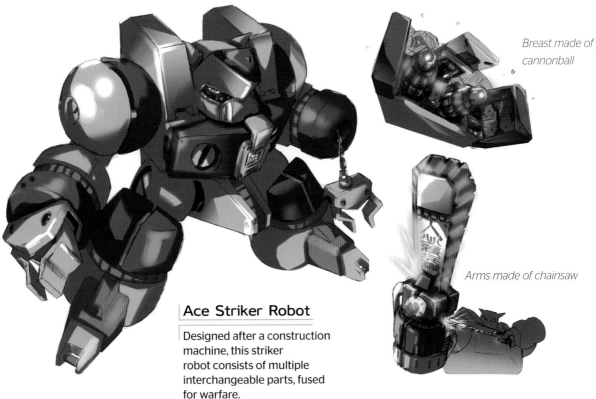

Breast made of cannonball

Arms made of chainsaw

Ace Striker Robot

Designed after a construction machine, this striker robot consists of multiple interchangeable parts, fused for warfare.

Robot + various weapon parts

Searchlight Robot

With a head and breast made of powerful searchlights, this investigator robot studies zones underground and beneath the sea that are uninhabited by humans.

Robot + coal miner + searchlight

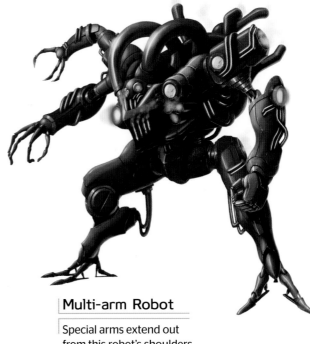

Multi-arm Robot

Special arms extend out from this robot's shoulders. Its complicated structure functions as a repairing robot.

Robot + insect + tools

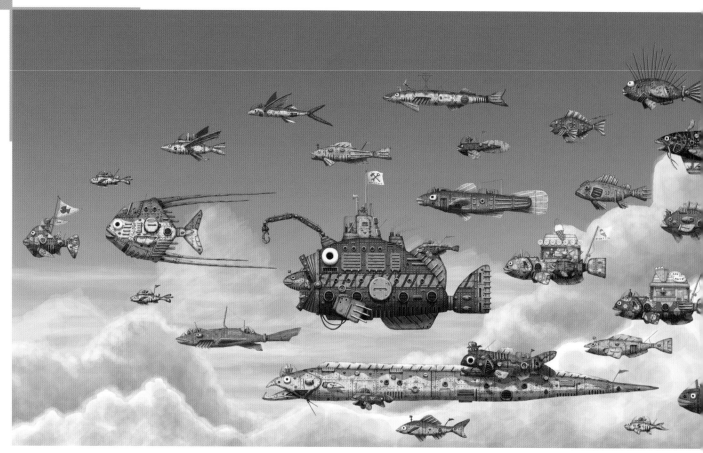

Fish Airborne Brigade

This colorful illustration displays many types of fish, floating as different kinds of humorous airships that fly around the skies, making one feel trapped in dreamland.

Various fish + various airships

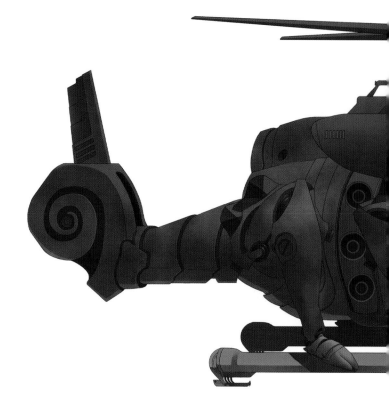

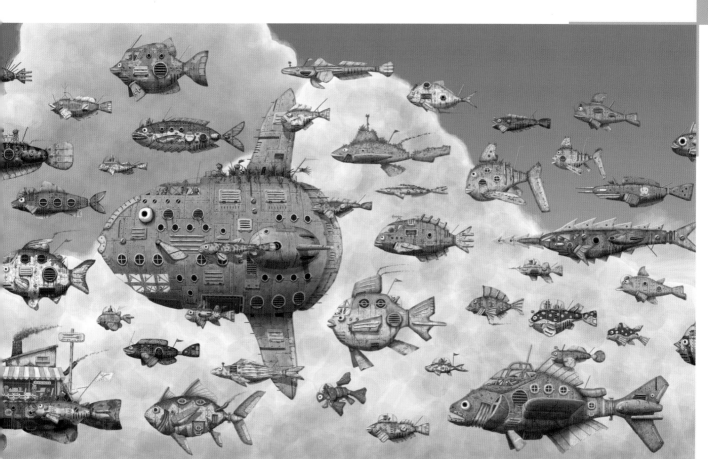

Chameleon Helicopter

The chameleon helicopter has a secret flight mission. Like the chameleon, it blends in with its surroundings. It flies quietly without being noticed.

Chameleon + helicopter

Addition

city of existence

都市

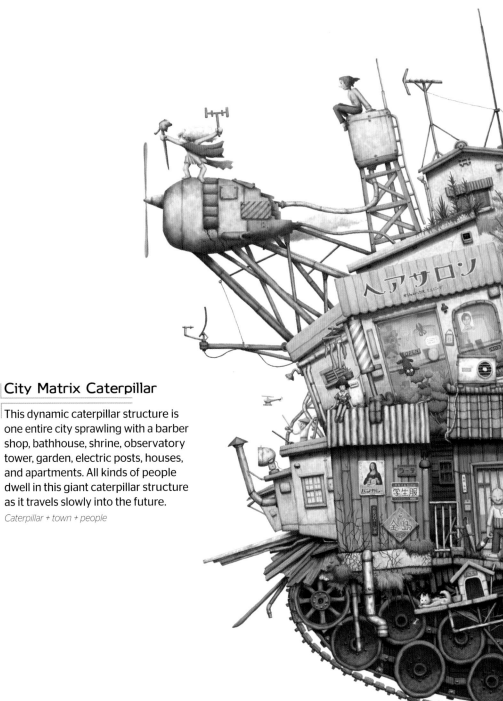

City Matrix Caterpillar

This dynamic caterpillar structure is one entire city sprawling with a barber shop, bathhouse, shrine, observatory tower, garden, electric posts, houses, and apartments. All kinds of people dwell in this giant caterpillar structure as it travels slowly into the future.

Caterpillar + town + people

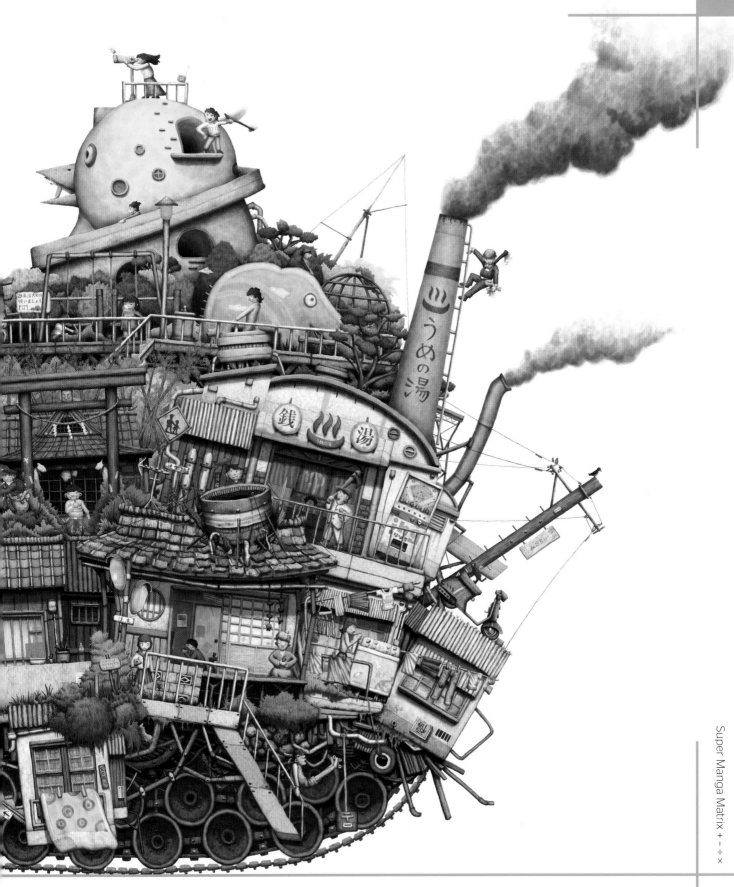

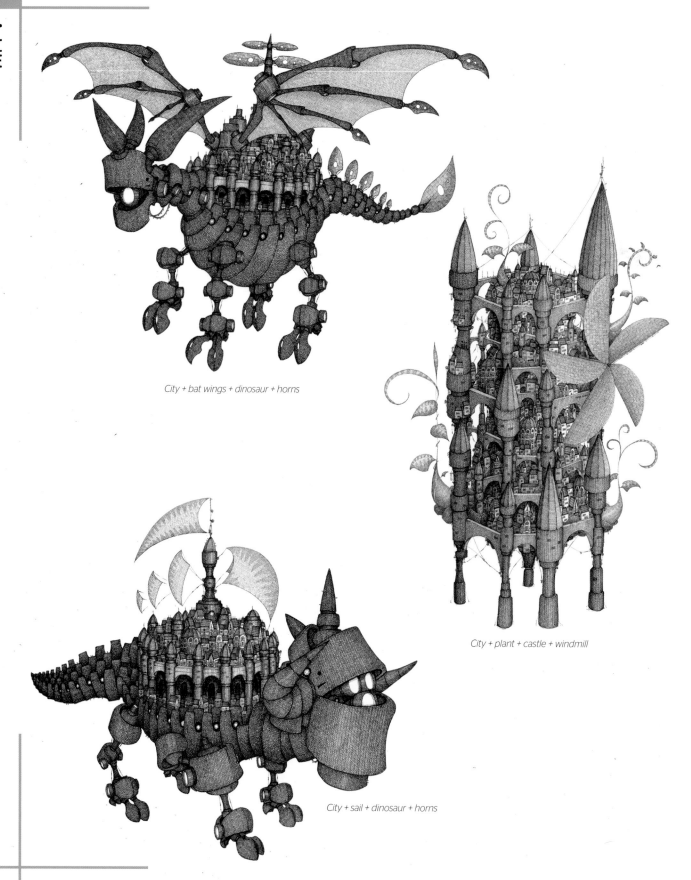

City + bat wings + dinosaur + horns

City + plant + castle + windmill

City + sail + dinosaur + horns

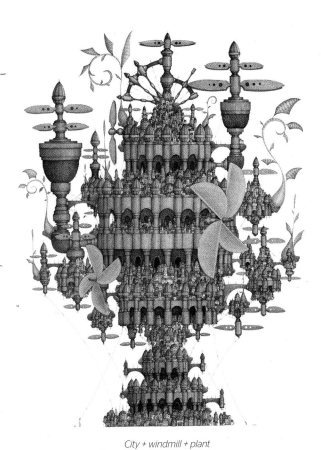

City + windmill + plant

Living City

By incorporating a powerfully driven windmill, or a dinosaur or other special monsters, a uniquely shaped city is created.

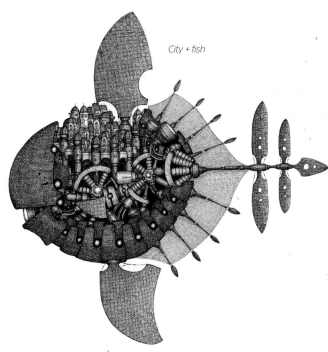

City + fish

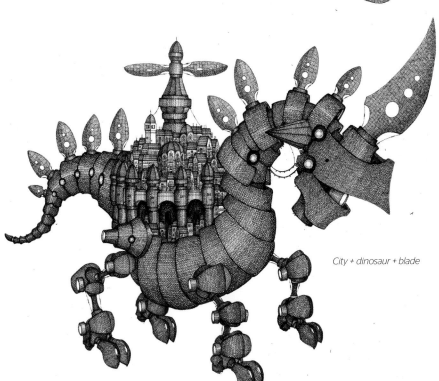

City + dinosaur + blade

Super Manga Matrix + - ÷ ×

Subtraction
Chapter 2

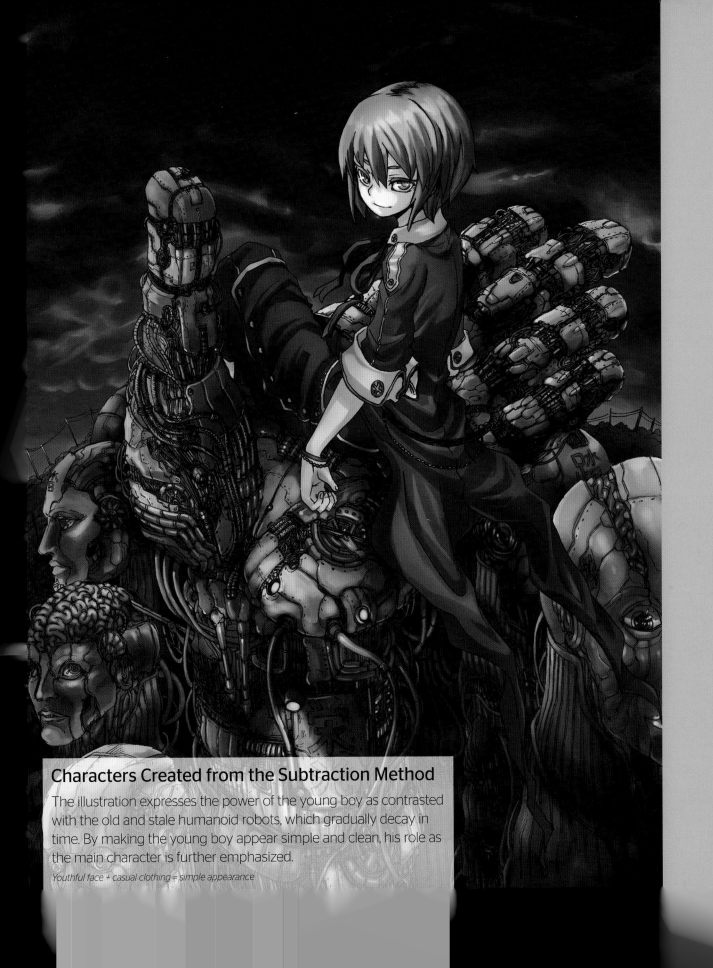

Characters Created from the Subtraction Method

The illustration expresses the power of the young boy as contrasted with the old and stale humanoid robots, which gradually decay in time. By making the young boy appear simple and clean, his role as the main character is further emphasized.

Youthful face + casual clothing = simple appearance

How to make characters using the Subtraction method

The previous chapter illustrated the Addition method, which is the most widely used technique in character creation. However, with that method, some characters may appear overly ornamented, especially if one does not use it wisely. Unlike the Addition method, wherein several characters are developed by adding significant features, the Subtraction method reduces the unnecessary elements or simplifies the other less attractive or important parts. Simplification can be done by reducing the size of the element, toning down its color, or making it less conspicuous. This can help to further highlight the part or feature you wish to emphasize.

Catgirl with Glasses

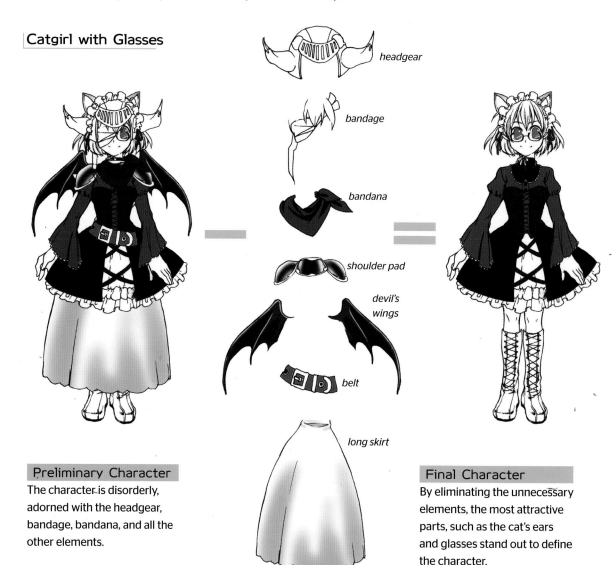

headgear

bandage

bandana

shoulder pad

devil's wings

belt

long skirt

Preliminary Character
The character is disorderly, adorned with the headgear, bandage, bandana, and all the other elements.

Final Character
By eliminating the unnecessary elements, the most attractive parts, such as the cat's ears and glasses stand out to define the character.

China Girl

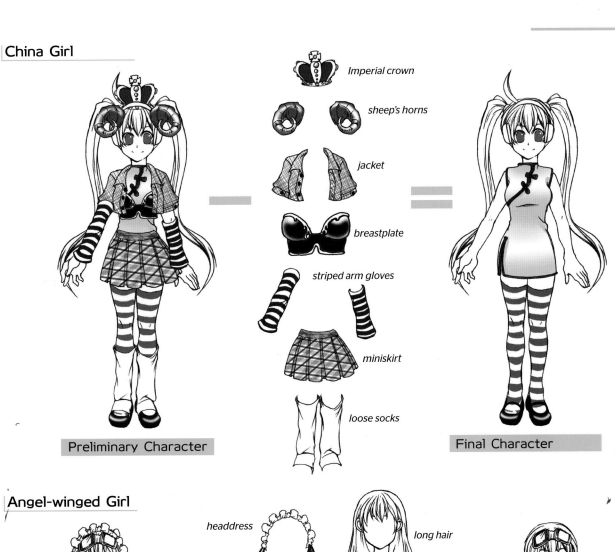

Imperial crown

sheep's horns

jacket

breastplate

striped arm gloves

miniskirt

loose socks

Preliminary Character

Final Character

Angel-winged Girl

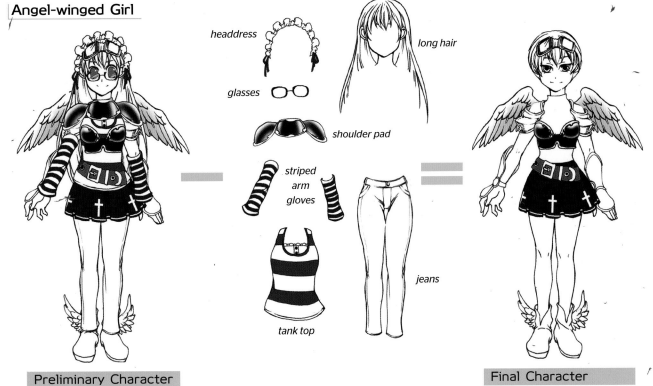

headdress

long hair

glasses

shoulder pad

striped arm gloves

jeans

tank top

Preliminary Character

Final Character

Chapter 2

individuality

Eliminating Unnecessary Elements

Several characters with varied personalities dominate a complicated story. In these cases, the characters' unnecessary features were eliminated in order to shape their essential individualities.

Different elements – unnecessary elements = individuality

Several elements that illustrate a devil were eliminated, but the horns that stick out from the head and shoulders were retained.

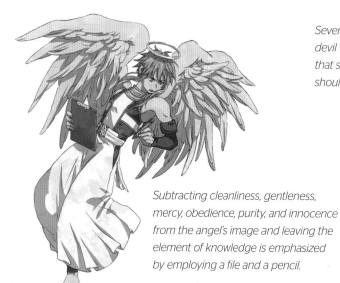

Subtracting cleanliness, gentleness, mercy, obedience, purity, and innocence from the angel's image and leaving the element of knowledge is emphasized by employing a file and a pencil.

Subtracting other poses and selecting the rotating pose, makes the vampire look like he is floating in the sky leisurely.

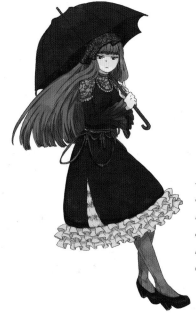

Subtract unnecessary accessories like a hat, mask, glasses, or doll and leave only one large accessory to draw attention to it.

Subtract other pose options and use a lying down pose with the character smirking to show comfort and confidence.

emphasis

強
調

Magma Monster

The magma monster possesses extreme energy to melt rocks. Unimportant elements made of flame, such as whip, sword, bow and arrow, and large tube were eliminated to leave only the power that makes the body a magma monster.

Various elements – unimportant elements = magma monster possessing extreme energy to melt rocks

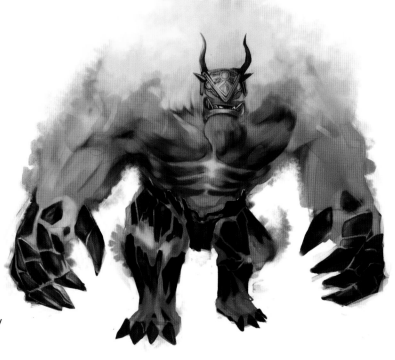

Absolute Zero Degree Monster

This monster has a temperature of absolute zero. Elements, such as cold bubbles, ice blowguns, cold air waves, and ice crossbow were previously considered, but later discarded to leave only the absolute cold air ability coming from the monster's body.

Various abilities – unnecessary abilities = Absolute Zero Degree Monster

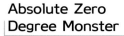

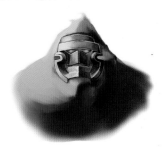

Chapter 2

simple costumes

簡素な衣装

Alpine Rose Team

The girls' attractive features are expressed well by merely simplifying the girls' clothes. The girls are compared to a flower—the image of an alpine rose is retained, among all the many possible flowers to choose from. The color white is also retained, which relates to the white color element of the sailor-style school uniform. The simplicity of the school uniform emphasizes the girl on the left, who wears a glove that signifies her special power.

Different flowers – unnecessary flowers = alpine rose;
Different colors – unnecessary colors = white

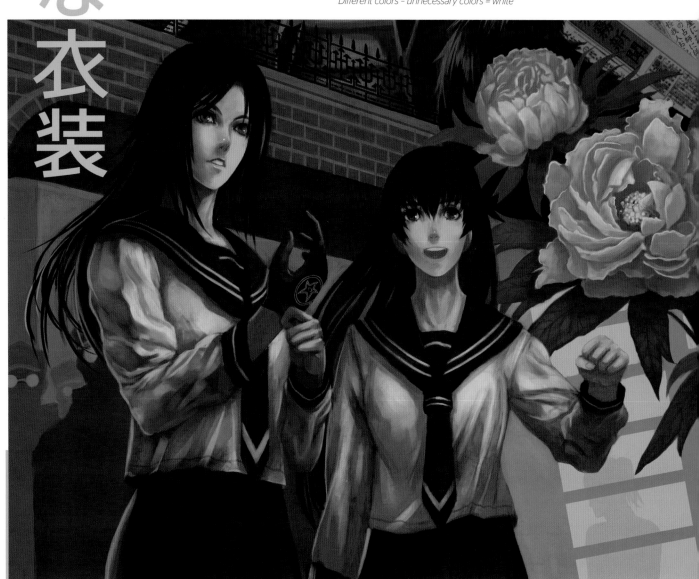

Dream Traveler

A girl travels through human spirits to a spiritual world, like a sea of lava. Several hairstyle options were subtracted. The short hairstyle option was retained to represent "passion" and an "active mind." Also, by subtracting unnecessary clothing adornments and leaving a simple-styled shirt and pants, the ribbon on the girl's head becomes very eye-catching.

Different hairstyles – unnecessary hairstyles = short-cut hairstyle

Different costumes – unnecessary costumes = simple shirt and pants

Midnight Lover

Colors were subtracted from this picture to emphasize the contrast between the worlds of black and white, and project a sharp and attractive rendering technique.

Many colors – unnecessary colors = black and white

Many animals – unnecessary animals = owl

capability - using manipulation

物ノ怪使い

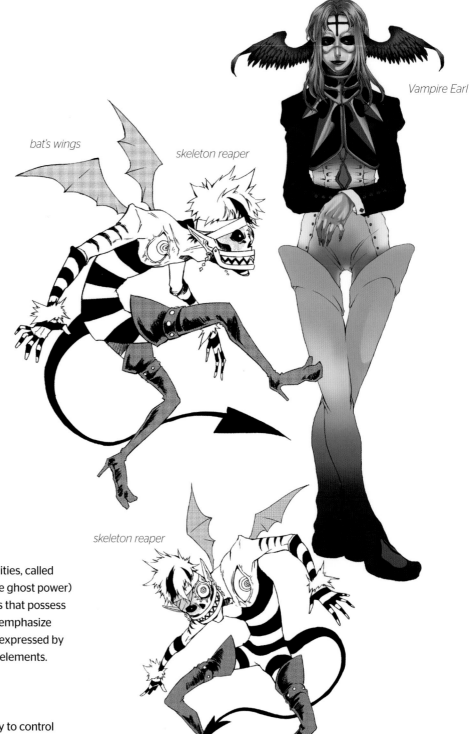

Vampire Earl

bat's wings

skeleton reaper

skeleton reaper

French cavalry high boots

The characters with unique abilities, called *mononoke tsukai* (ones who use ghost power) are among the many characters that possess a wide range of capabilities. To emphasize their personalities, simplicity is expressed by subtracting other unnecessary elements.

Vampire Earl

The Vampire Earl has the ability to control a grim skeleton reaper. His costume is extremely simple and unique, inspired by themes from masquerade costumes.

Different abilities - unnecessary abilities = power of manipulating the skeleton reaper

Boy In a Festival

This boy has the ability to control the dancing lion beast, which symbolizes a festival. The boy's costume is simple in order to emphasize his peculiar ability.

Different abilities – unnecessary abilities = ability to control the dancing lion beast

Wisteria Shrine Maiden

The dragon bones, surrounded by Japanese wisteria, wrap a young shrine maiden. The dragon's life relies on the girl's will. Extra decorations on the girl are eliminated to emphasize her ability to control the dragon.

Different abilities – unnecessary abilities = ability to control a dragon

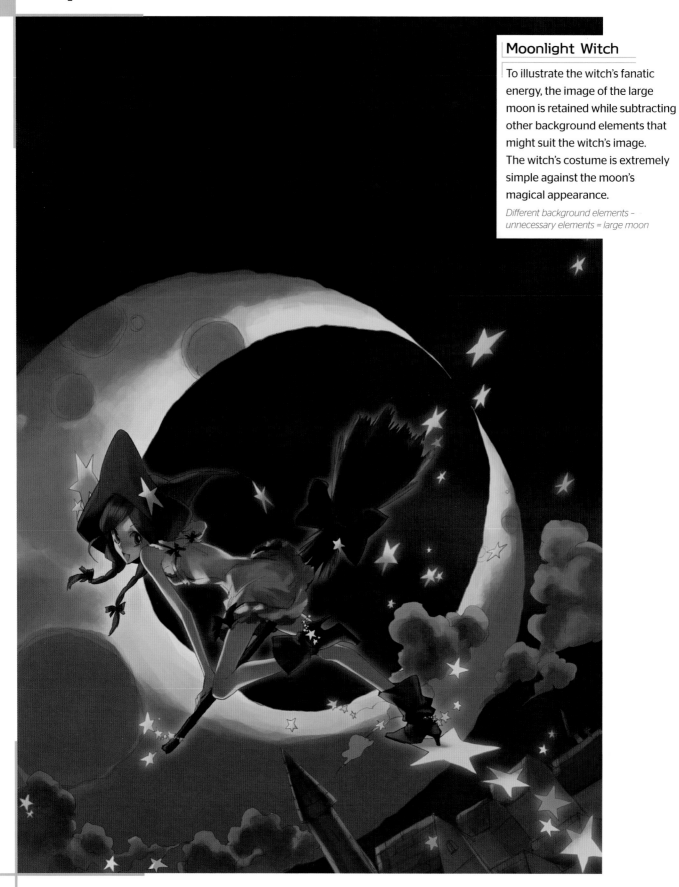

Moonlight Witch

To illustrate the witch's fanatic energy, the image of the large moon is retained while subtracting other background elements that might suit the witch's image. The witch's costume is extremely simple against the moon's magical appearance.

Different background elements – unnecessary elements = large moon

capability - using magic

魔法

The characters shown here are not superheroines with various kinds of abilities; these characters retain one specialized magic ability using the subtraction method.

Halloween Witch

To illustrate a charming witch, her hat is retained while subtracting other elements.

Different witch items - unnecessary items = witch's hat

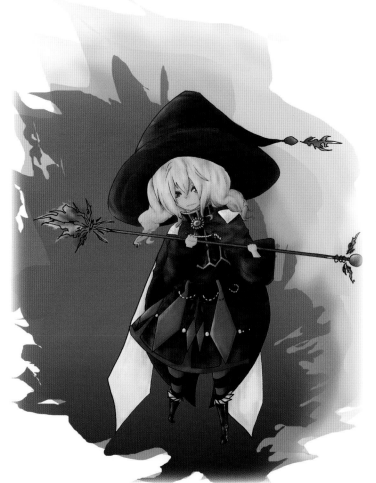

Apprentice Witch

The witch's flight ability is retained by subtracting other various kinds of elements that describe a witch. The winged costume replaces the traditional broom.

Different witch items - unnecessary items = winged costume

Chapter 2

tool - umbrella

Girls with Umbrellas

The umbrella is often used as an accessory. Rain symbolizes sorrow or trouble. The girls depicted here are simple and charming. The illustrations eliminate other elements and retain the umbrella.

Elements that symbolize a girl's sorrow or troubled emotion - different elements = rain → umbrella

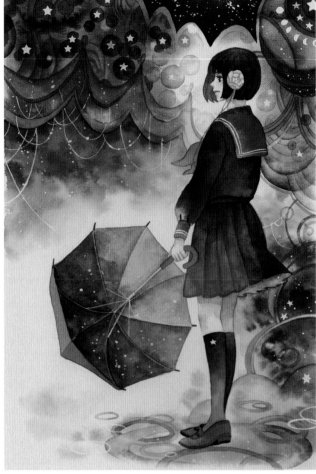

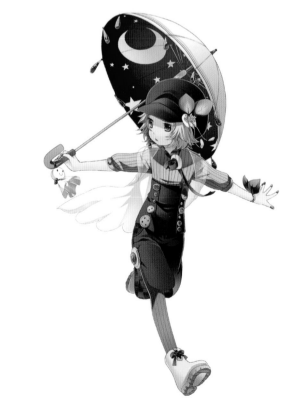

Super Manga Matrix + − ÷ ×

Division
Chapter 3

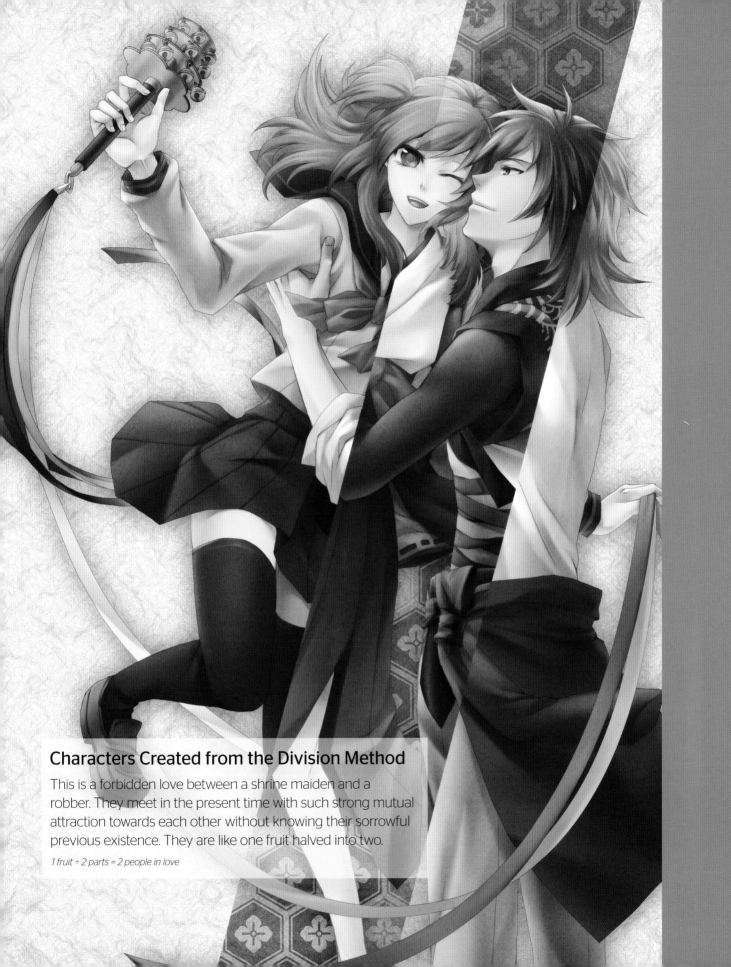

Characters Created from the Division Method

This is a forbidden love between a shrine maiden and a robber. They meet in the present time with such strong mutual attraction towards each other without knowing their sorrowful previous existence. They are like one fruit halved into two.

1 fruit ÷ 2 parts = 2 people in love

How to make characters using the Division method

A single character may have different personalities within. He may be an epitome of Dr. Jekyll and Mr. Hyde; a saint who also breathes an insane self; or a shadow of Billy Milligan, who was diagnosed with multiple personality disorder. The Division method of character making allows the character to extract an insane feature or a tragic side from within that releases its shadow or weakness. This tragic element becomes the ultimate attractive feature of the character.

Sample 1:
Multiple personalities in one body

Multiple Personalities

This character can possess multiple personalities: pessimistic, quiet and kind, cunning, immoral and evil.

Heart ÷ 4 personalities = 1 character

Minotaur

Minotaur is a Greek mythological creature that has the head of a bull monster and a heart, mind, and body of a human being.

1 body ÷ 2 = Minotaur

Cerberus

Cerberus is a Greek mythological dog creature that has three heads, exuding different characters combined into one body. It lives and fights with this inconsistency.

1 head ÷ 3 = Cerberus's head

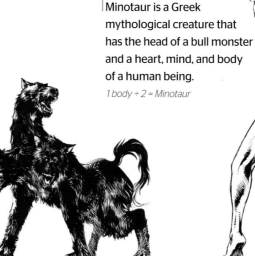

Sample 2: One heart divided into multiple personalities

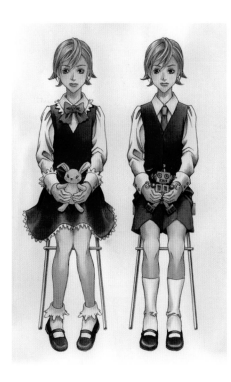

Hidden Key

The doll in this picture has many boxes of personalities with their own keys. The doll lies down while waiting for someone to open the keys to every box.

Doll's heart ÷ infinite number of boxes = personalities in boxes

Twin Siblings

Twins look alike, dress alike, and sport a similar hairstyle, yet may have opposing personalities. They are typical characters using the Division method.

1 set of genes ÷ 2 bodies = twins

Sample 3: Heart and body divided into two

Girl with Astral Projection

This girl has the ability to release the heart from the body. The released heart cannot be seen by others. She flies freely around the astral world and the human world.

One body ÷ 2 elements = astral body and physical body

Chapter 3

twins

双子

Twin Children

Twins are born on the same day, and are raised in the same environment in the same way. Yet, they often have different personalities. They live as though they have been split from one person.

1 set of genes ÷ 2 = twins

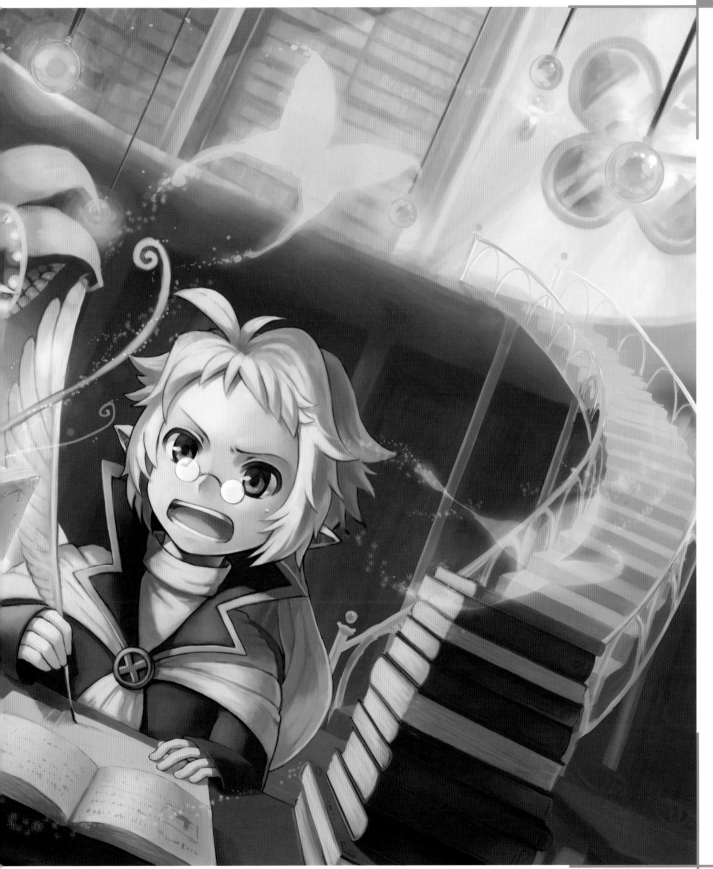

Flower Brother and Sister

The brother and sister have different personalities, but unite in their strength, which makes them more attractive and powerful.

1 set of genes ÷ 2 = twins

Kompeito Sugar Candy Brothers

These twin brothers are like Japanese Kompeito sugar candies that stick together through thick and thin. Their power lies in their mischievous behavior.

1 set of genes ÷ 2 = twins

split self

分裂

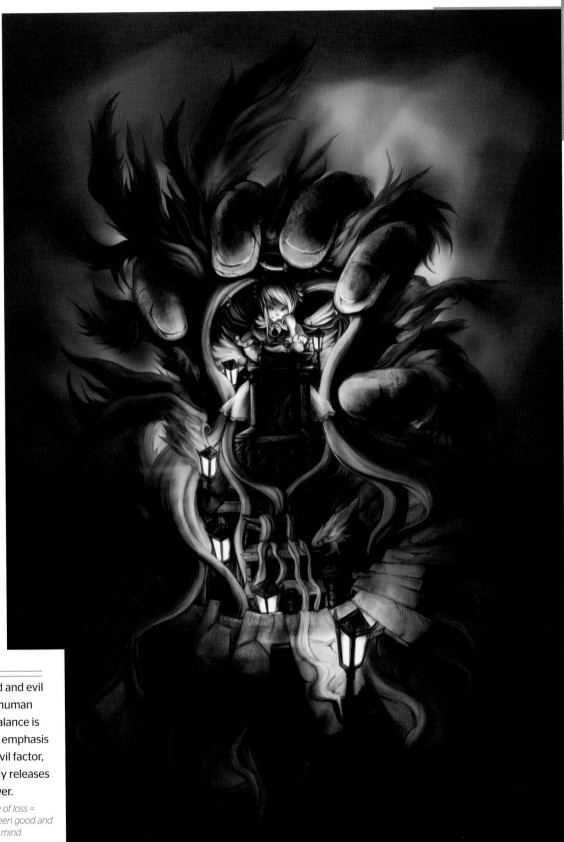

Devil Chair

A balance of good and evil
dwells inside the human
soul. When this balance is
shaken and more emphasis
is placed on the evil factor,
one unconsciously releases
a frightening power.

*Human spirit ÷ feeling of loss =
broken balance between good and
evil inside the human mind*

宿
命

Broken Friendship

Two former friends are wounded,
but they have to continue fighting
each other until one loses. Their
spirits will sink during the battle.

Friendship ÷ 2 = sorrow

sadness

哀しみ

Young Soldier's Sorrow

The dead army general cannot accept his own death, and instead, looks sadly at the hair ornament given to him by a dear loved one. This story is about one love that is bound by fate and leads to sorrow.

One love ÷ 2 = sorrowful fate

psyche

心理

Surprise Box

This gentle girl possesses two personalities. The box represents her deep psychic desires. The clown girl that jumps out of the box is her second personality that she never knew existed.

1 heart ÷ multiple desires = multiple personalities

Angel and Devil

A person consists of a portion of light and a portion of shadow, and the angel and the devil embody these two elements. The battle between the angel and the devil expresses conflict inside one's heart. How the angel can attain victory in this sublime battle is yet to be seen.

Inner self ÷ 2 = light (angel) and shadow (devil)

Multiplication
Chapter 4

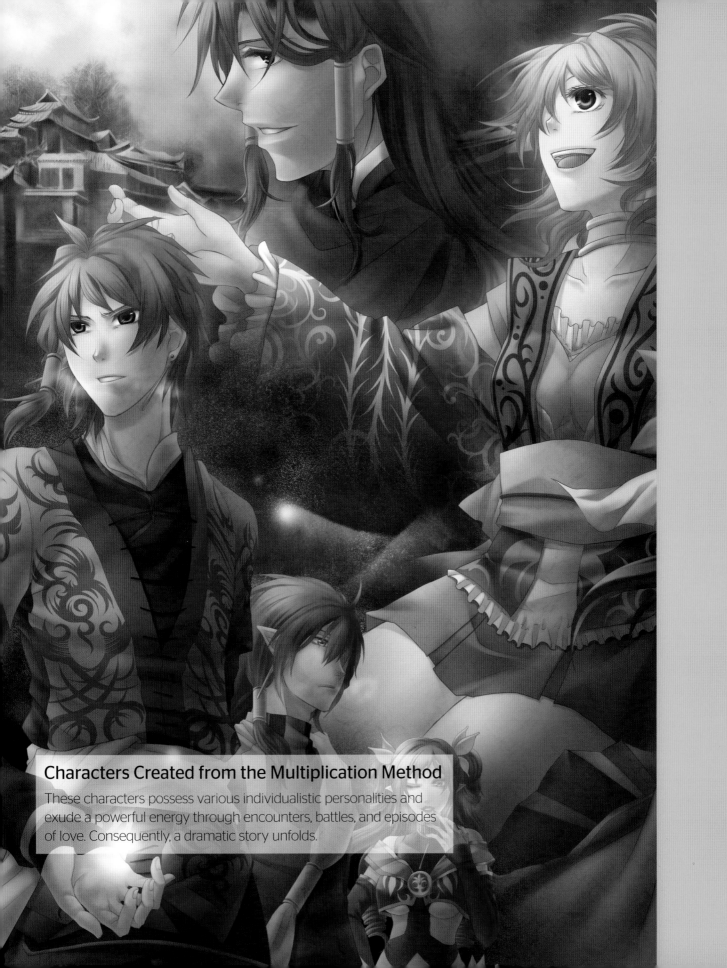

Characters Created from the Multiplication Method

These characters possess various individualistic personalities and exude a powerful energy through encounters, battles, and episodes of love. Consequently, a dramatic story unfolds.

How to make characters using the Multiplication method

In creating a full story with many characters involved, each character displays a unique personality that consequently interrelates with the others. The fusion of these characters energizes their presence and gives more life and attractiveness to the entire story. This is called the Multiplication method.

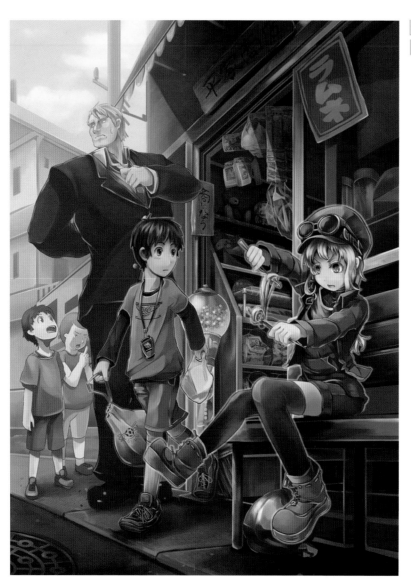

Encounter

People of varied ages, sex, and occupation meet in the city as part of daily life. As a result of the Multiplication method, several mysterious stories can arise from such encounters. In this illustration, a boy, Kenta, is on his way to cram school. Another boy, Toshi, is praying that he wins the lottery. A celebrity's daughter, Fujiko, tries to chase the culprit of the kidnapping incident that had just occurred nearby, while her bodyguard Shijo, who stands by, disturbs Ryota, the boy who cannot buy anything at the mom-and-pop store. All these characters will meet in this store, and find themselves developing friendships while solving the crime incident.

Mom-and-pop candy store x leading lady x leading man x bodyguard x two shoppers x friendship

Fox Spirit's Love

The most powerful element in the Multiplication method is love. It can multiply manifold and have a great effect on the characters.

Male fox x woman x love story

Monster Family

This monster family consists of different characters with varied abilities: for example, [anthropophobic daughter = moral shock] x [playful father = clairvoyant powers x meddlesome mother = sense power] x [sarcastic grandfather = fortune teller]. These characters make up an entire human community that runs a small playhouse where many interesting incidents occur in their daily lives.

Monster family (daughter x father x mother x grandfather) x human world x playhouse

Chapter 4

encounter

出会い

Girl with an Iguana

A girl dozes peacefully on a field of flowers as an oddly shaped iguana approaches. The silent appeal of the iguana quietly awakes her, and then, the drama begins.

Girl x iguana x flowers

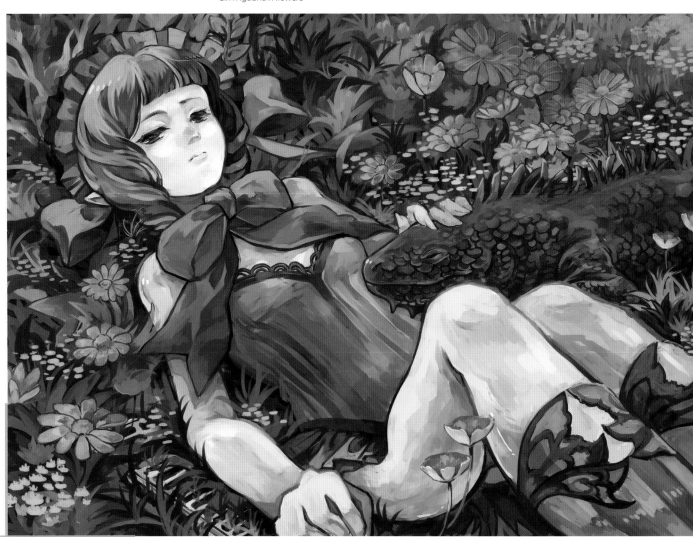

Uncertain Awakening

A snake sneaks up to a girl who is heavily protected in the secluded world where she has been hiding. The snake is a symbol of attractive temptation, knowledge, desire, and pleasure. Great energy is born from this encounter with a different being.

Beautiful maiden x snake x apple

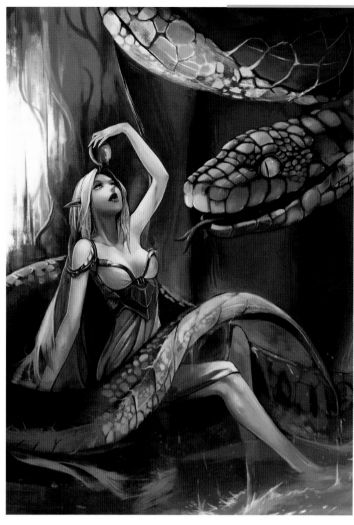

Two Children and a Strange, Little Horse

These two children are caught in the power of the sea, when their protector sends an auspicious, little horse to them. Their encounter creates a new, magnificent world.

Sea x girl and boy x horse

Chapter 4

departure

旅立ち

Departure

A lamppost watches over an old, obsolete train that no longer runs, and a girl in a wheelchair approaches. The lamppost receives a strange and mystical energy that lights up the girl and the train. The girl suddenly stands up, and the train starts to move. A new departure begins.

Train x wheelchair x girl x lamp x night energy

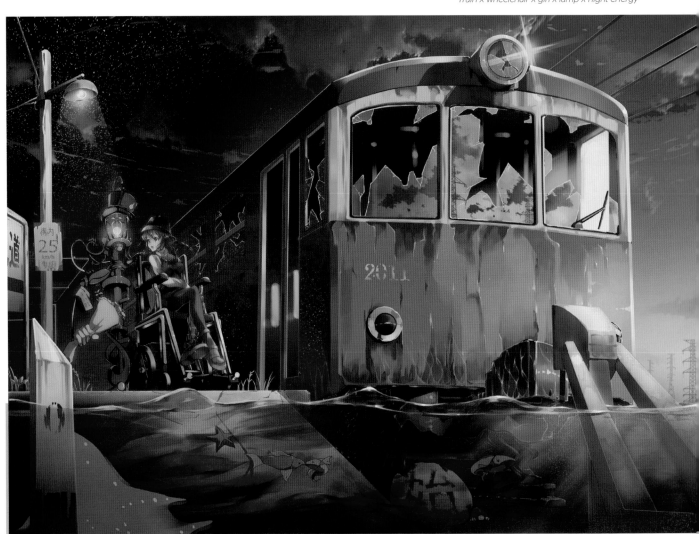

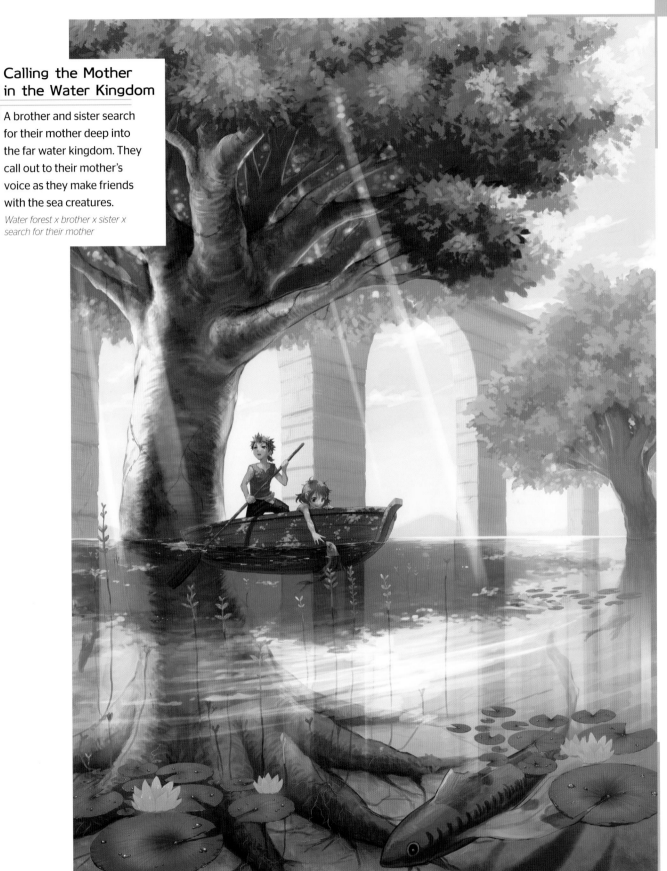

Calling the Mother in the Water Kingdom

A brother and sister search for their mother deep into the far water kingdom. They call out to their mother's voice as they make friends with the sea creatures.

Water forest x brother x sister x search for their mother

Chapter 4

beginning

始まり

Mystery of the Skeletal Dragons

Two people who are drawn to the mystery of the ancient, gigantic dragons meet in the snowy field where the dragons' fossils sleep. Their encounter awakens the giant dragons that had been in deep sleep, and triggers a magnificent tale between humans and the dragon family.

Giant dragon x bones x old tale x young, female archaeologist x bone bric-a-brac shop owner's son x robot dog

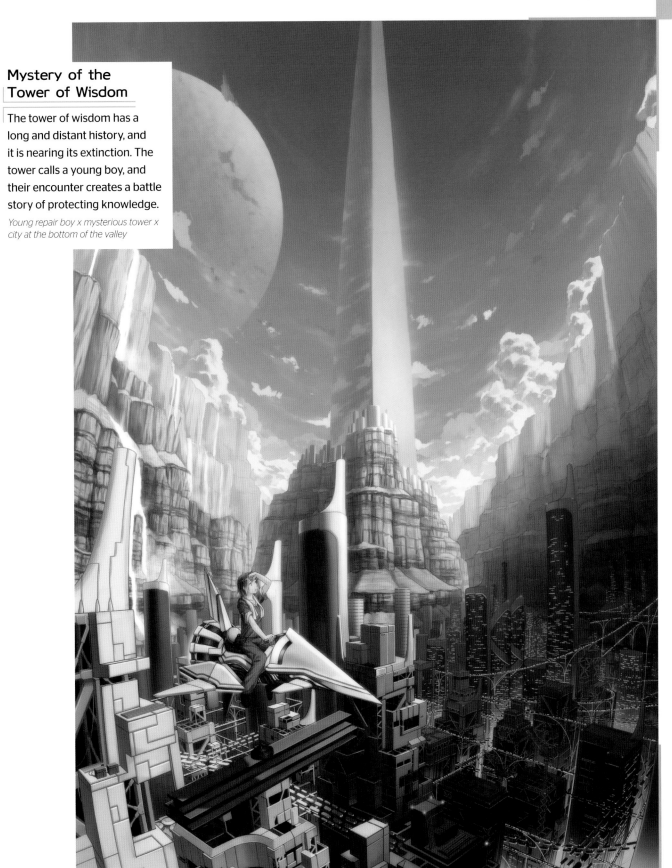

Mystery of the Tower of Wisdom

The tower of wisdom has a long and distant history, and it is nearing its extinction. The tower calls a young boy, and their encounter creates a battle story of protecting knowledge.

Young repair boy x mysterious tower x city at the bottom of the valley

Chapter 4

adventure

Threesome Friends

The three main characters in this scenario each possess wisdom, passion, and courage. When they gather, nothing can be feared. Their dramatic story unfolds a world of adventure.

Boy who lives on love and knowledge x bald eagle x wildcat that teaches about courage

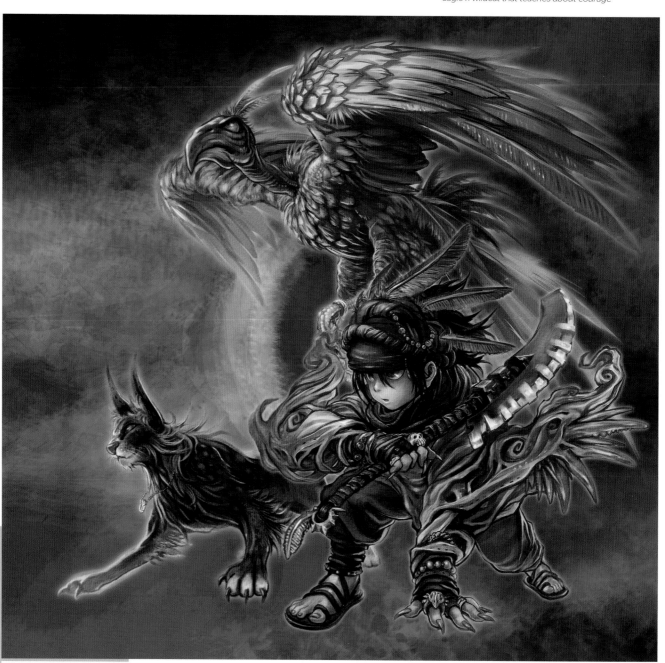

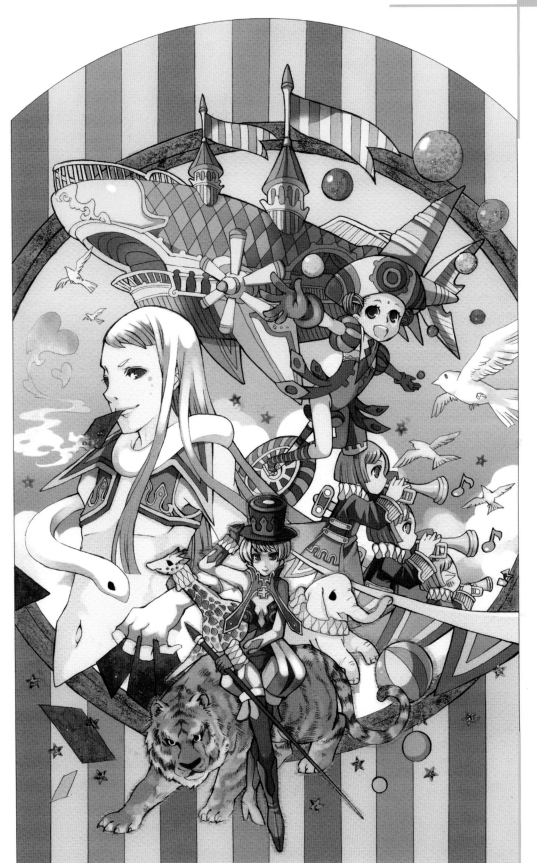

Circus Adventure

A circus troupe consists of humans and animals with various backgrounds. They travel every day from town to town, wrapped in dreams and adventures.

Savage beast x magician x robot orchestra x aerial acrobatics x future aerial circus troupe

friends

仲間

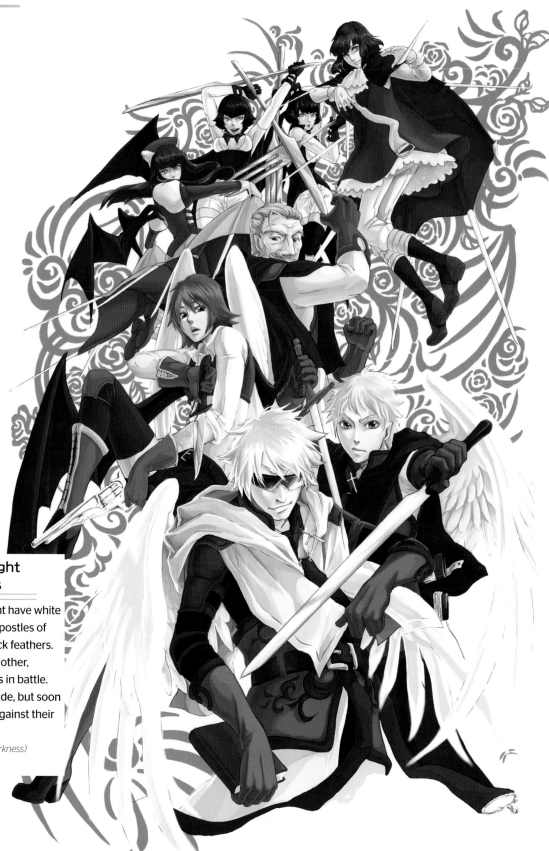

Friends of Light and Darkness

The apostles of light have white feathers, and the apostles of darkness have black feathers. They oppose each other, but join their hands in battle. Together, they collide, but soon reconcile to fight against their common enemies.

Angel (light) x devil (darkness) x collision x friends

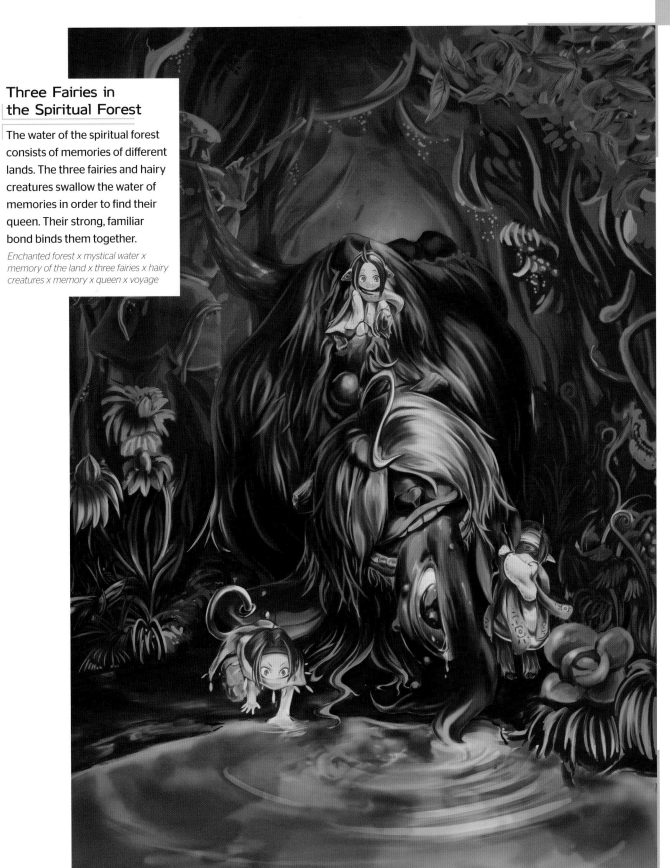

Three Fairies in the Spiritual Forest

The water of the spiritual forest consists of memories of different lands. The three fairies and hairy creatures swallow the water of memories in order to find their queen. Their strong, familiar bond binds them together.

Enchanted forest x mystical water x memory of the land x three fairies x hairy creatures x memory x queen x voyage

Chapter 4

family

家族

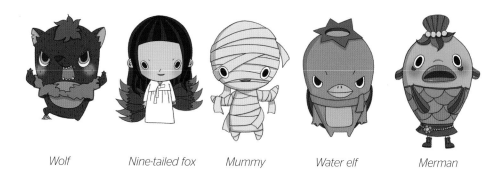

Wolf *Nine-tailed fox* *Mummy* *Water elf* *Merman*

Monster Family Mansion

All kinds of monsters, with various features, live together in this mansion. Each monster occupies its own room that is a unique monster world of its own. A human who enters a room by mistake can no longer leave the premises. Gathering all these monsters together forms a fascinating story.

Wolf man x nine-tailed fox x mummy x water elf x vampire x witch x zombie brother and sister x Frankenstein x monster mansion

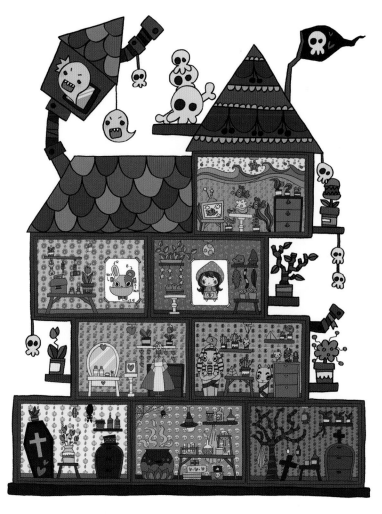

Vampire *Witch* *Zombie brother and sister* *Frankenstein*

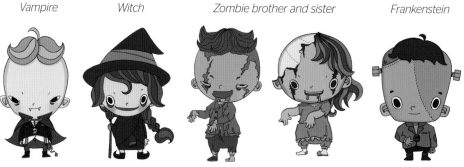

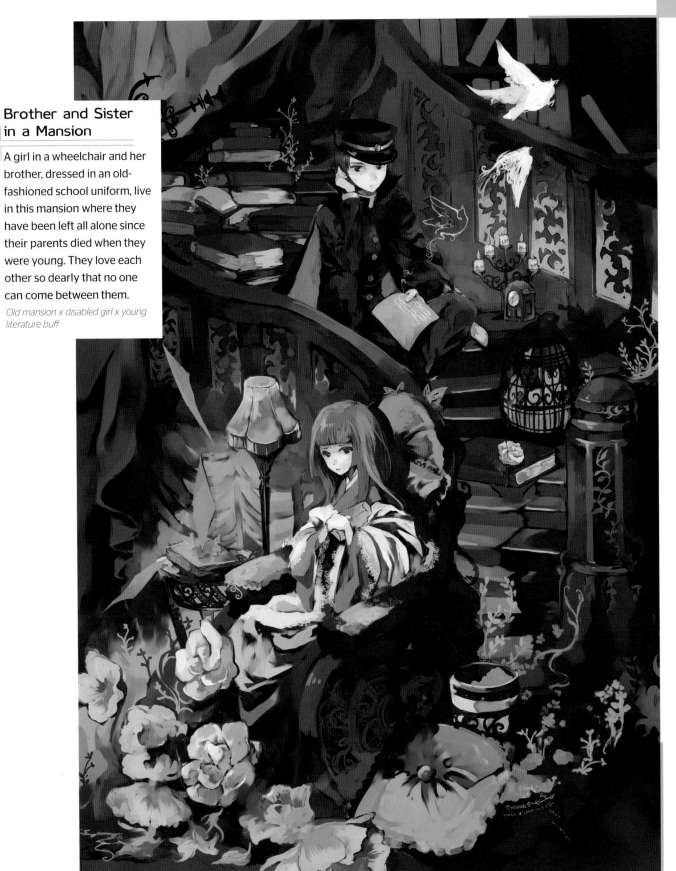

Brother and Sister in a Mansion

A girl in a wheelchair and her brother, dressed in an old-fashioned school uniform, live in this mansion where they have been left all alone since their parents died when they were young. They love each other so dearly that no one can come between them.

Old mansion x disabled girl x young literature buff

Chapter 4

crowd

集団

Witch's Roulette

The witch stands in the middle of the roulette. When she spins the roulette, the character that faces her must relate its own story. When she spins the roulette again, another character relates its story. The witch can expand and interchange the stories.

Children's story x witch x roulette

The Neighborhood

Students, teachers, parents, and children with various personalities all live in one neighborhood. Their daily lives may be simple, but evolve around many interesting stories.

Perverse x temperamental x obstructive x dull x prone to anorexia x sarcastic x narcissist x curious x group theater

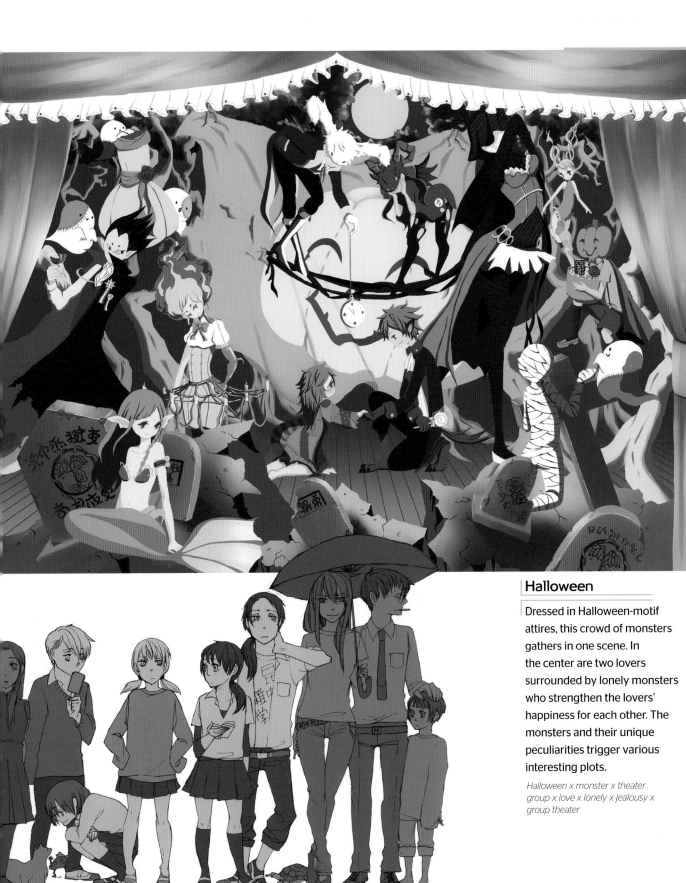

Halloween

Dressed in Halloween-motif attires, this crowd of monsters gathers in one scene. In the center are two lovers surrounded by lonely monsters who strengthen the lovers' happiness for each other. The monsters and their unique peculiarities trigger various interesting plots.

Halloween x monster x theater group x love x lonely x jealousy x group theater

Chapter 4

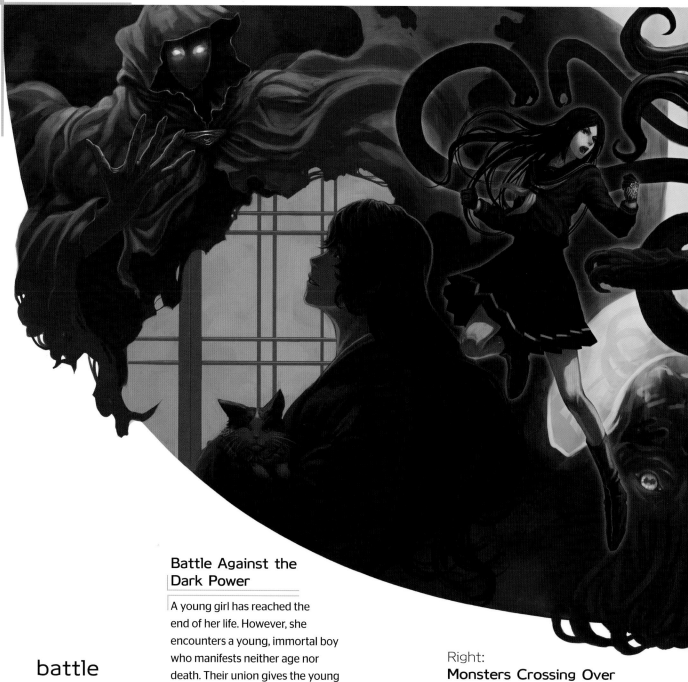

battle

Battle Against the Dark Power

A young girl has reached the end of her life. However, she encounters a young, immortal boy who manifests neither age nor death. Their union gives the young girl greater power, which the devil discovers, and the devil begins to attack her. With the young girl's power of deep, mystical love, combined with the young boy's wisdom, the devil struggles in a fierce battle against her.

Young girl x ageless and immortal boy x dark magician x knowledge x spirit x affection x awakening x myth x tale x battle

Right:
Monsters Crossing Over the Boundary Zone

In ancient times, humans and monsters coexisted. However, as time elapsed, for some reason it became impossible for monsters to enter into the human realm. By asserting their power in the world of darkness, they were able to topple the human sacred world and once again, live with the humans.

Monsters x human sacred world x dark world x humans

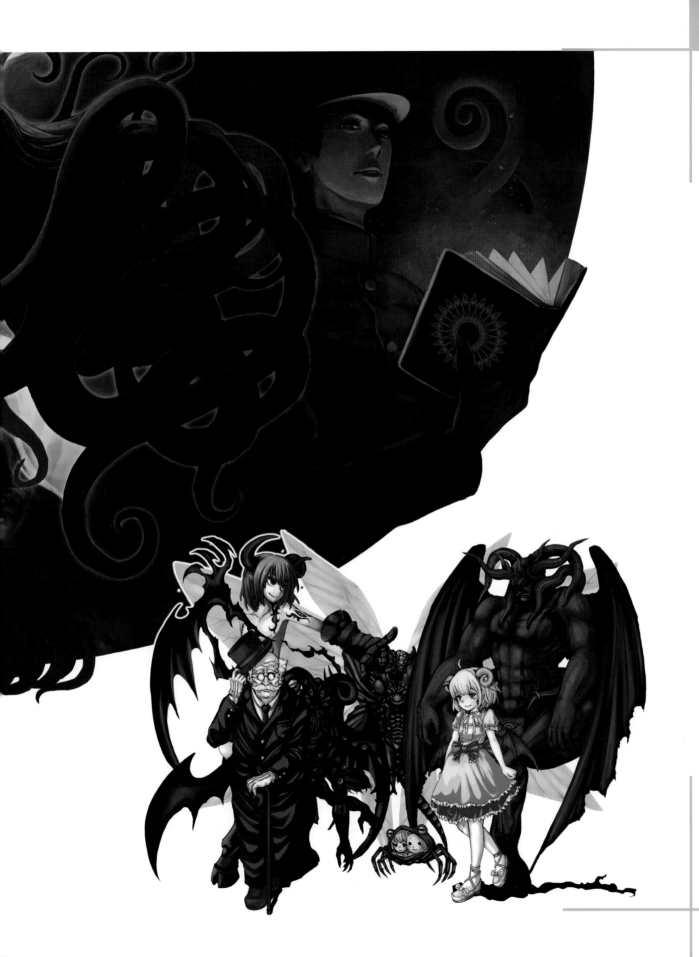

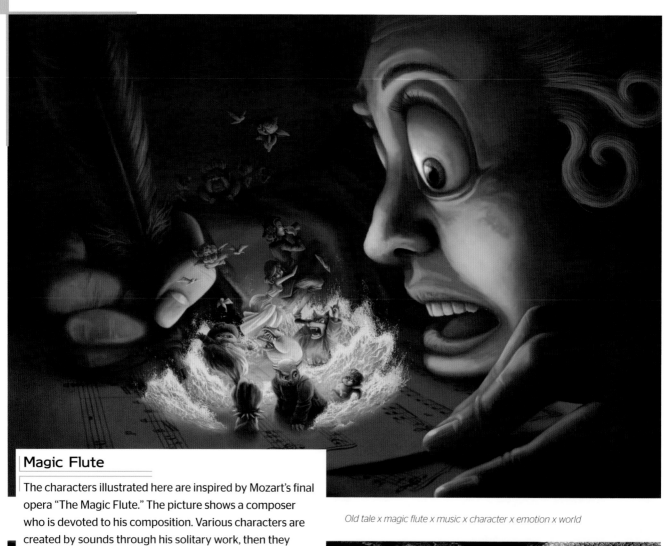

Magic Flute

The characters illustrated here are inspired by Mozart's final opera "The Magic Flute." The picture shows a composer who is devoted to his composition. Various characters are created by sounds through his solitary work, then they begin to appear in the scenario. The characters create a virtual world that includes the composer.

Old tale x magic flute x music x character x emotion x world

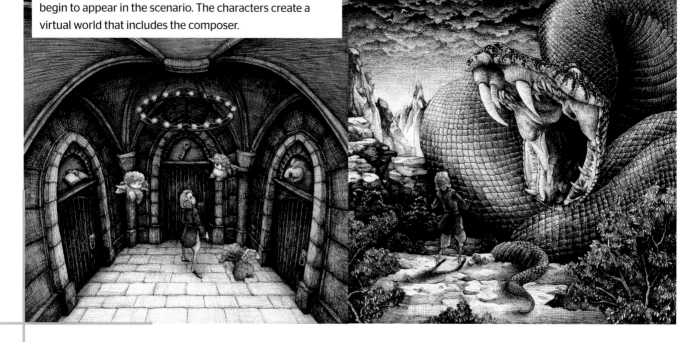

myths

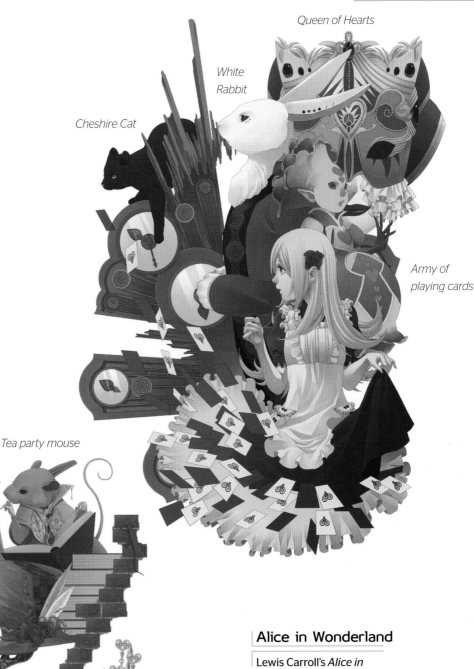

Queen of Hearts

White
Rabbit

Cheshire Cat

Army of
playing cards

Fish noble class

Tea party mouse

Tea party
March hare

Alice in Wonderland

Lewis Carroll's *Alice in Wonderland* is an example of a surrealistic fairy tale that is filled with many interesting and charming characters.

Children's tale x wonder x Alice x White Rabbit x Queen of Hearts x Cheshire Cat x other characters

city

都
市

Living City

Man builds and governs the city while an expanding blood vessel-like computer network surrounds the city and resurfaces it as one living entity. The new city rules over the human beings who live in this world.

City x night x light x computer x network x control

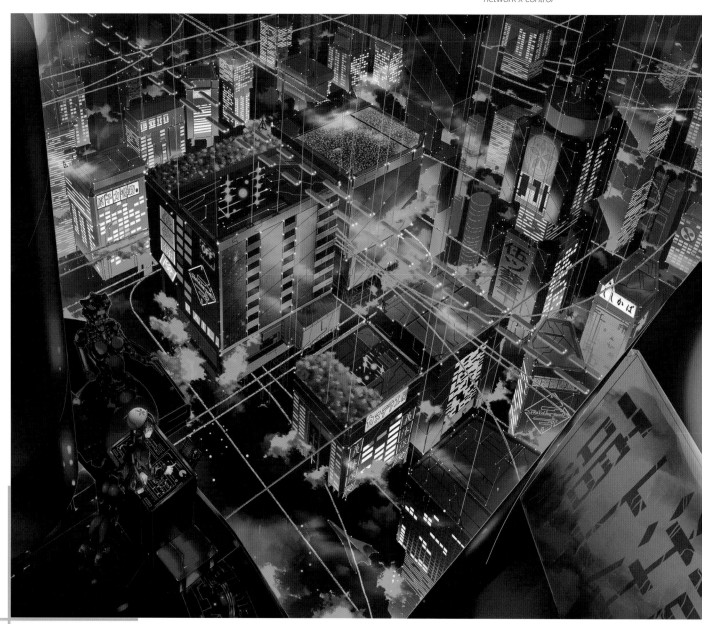

Stories Built from Cities

Cities are dynamically filled with people of various ages, who meet under many different circumstances, fall in love, dispute, grieve, laugh, become angry, and display all kinds of other emotions. A wide range of stories can be created from these cities.

City x people x encounters x buildings x vehicles

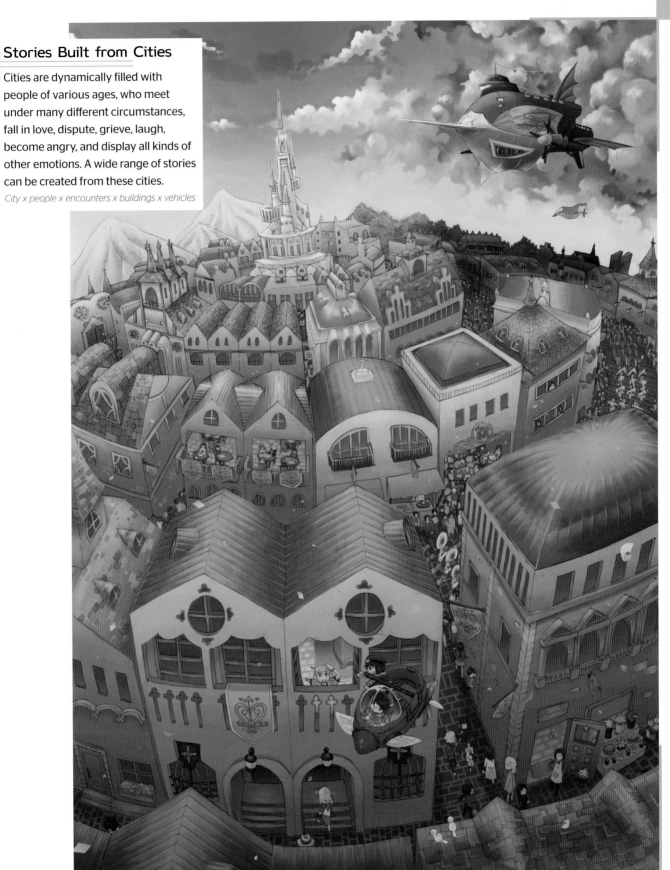

Chapter 4

wonder

不思議

The Girl and the Supernatural Bridge

When the girl tries to cross the supernatural bridge, the devilish fox and rabbit obstruct her way. Difficult and mysterious problems befall her, and the strange tale begins.

Supernatural bridge x magic rabbit x young girl x complicated problem

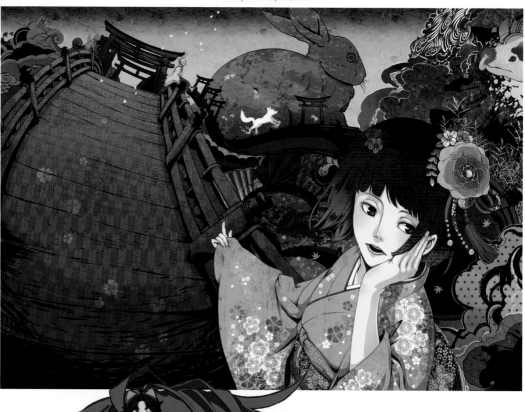

Characters Living in a Face

Strange, little characters live in this face and selfishly transform the face into various expressions. They make the face laugh, cry, or become furious.

Face x expression x little characters

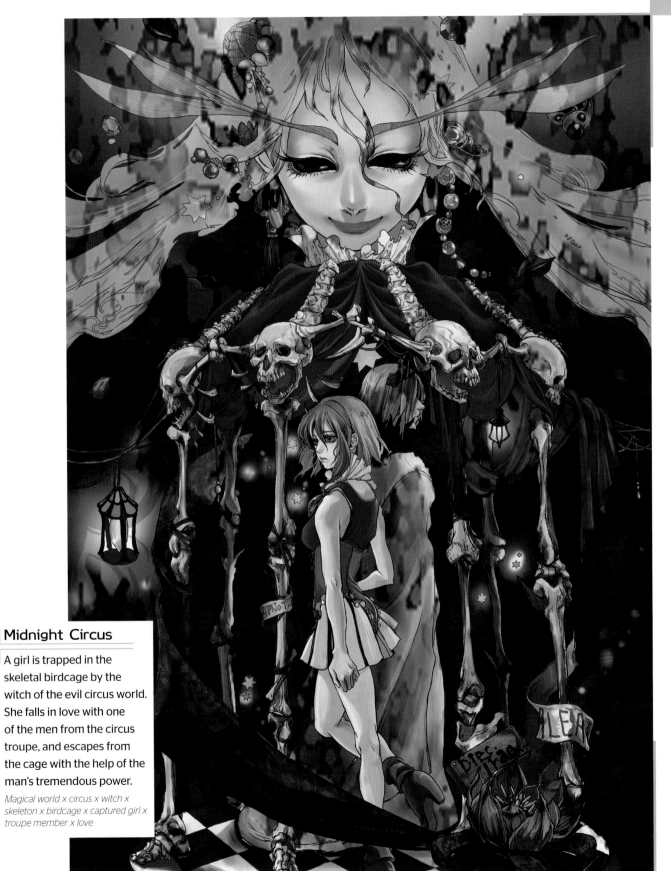

Midnight Circus

A girl is trapped in the skeletal birdcage by the witch of the evil circus world. She falls in love with one of the men from the circus troupe, and escapes from the cage with the help of the man's tremendous power.

Magical world x circus x witch x skeleton x birdcage x captured girl x troupe member x love

Chapter 4

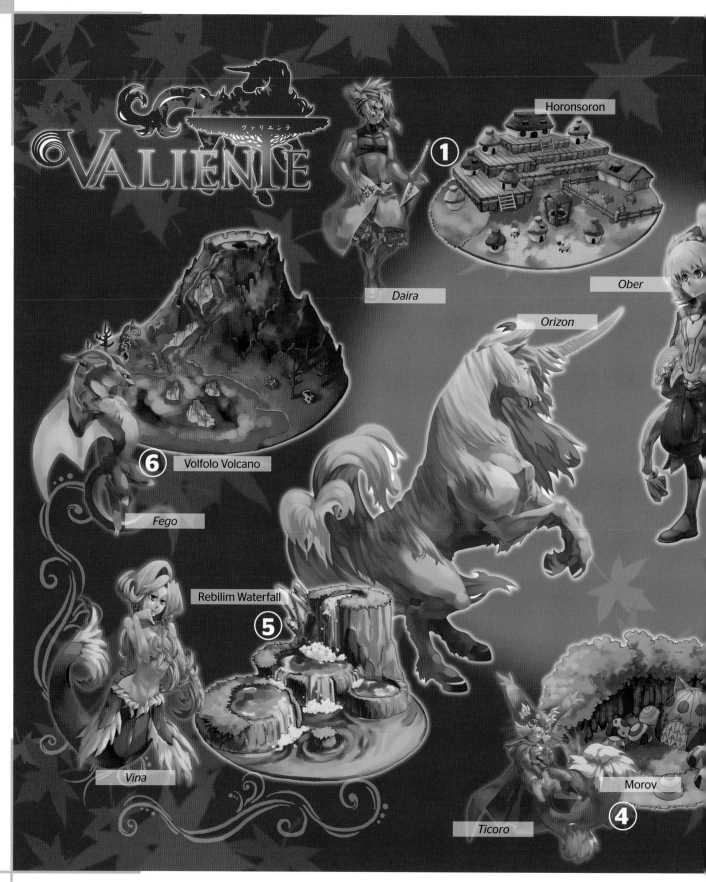

Valiente

Horonsoron **①**

Daira

Ober

Orizon

Volfolo Volcano **⑥**

Fego

Vina

Rebilim Waterfall **⑤**

Morov

Ticoro

④

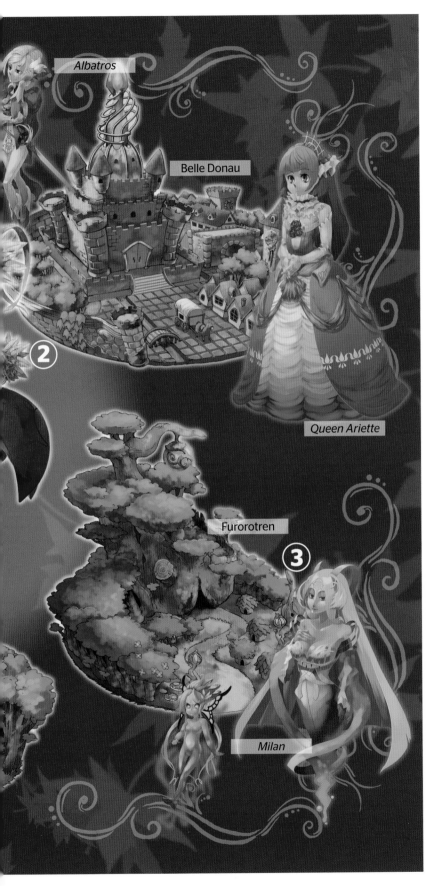

Albatros

Belle Donau

Queen Ariette

②

Furorotren

③

Milan

story

物語

Humans x fairies x dragon x mermaid x beast x complication x coexistence

World of Humans and Fairies

Humans, fairies, dragons, mermaids, and beasts coexist in this world. They are enveloped in a circle of conflicts. The hero, with his favorite horse, shall unite all races.

1. Horonsoron. This village is inhabited by a race that is a mix of humans and fairies. ***Ober***, the forgotten prince who grew up in this frontier village, is the good friend of ***Daira***, the village mayor's son, who longs for a rich life in the town of humans, and dreams of becoming a hero. ***Orizon*** is Ober's favorite horse and the divine beast that gallops along the horizon.

2. Belle Donau. The king of the Belle Donau kingdom of humans has died, and the tribes are fighting each other for the crown. The Duke of ***Albatros***, who claims to be the next king, is the nobleman who tries to overthrow the throne. He sends assassins to assail ***Ober***, who has proof of obtaining the power for ruling the kingdom. ***Queen Ariette***, the queen of peace, smells the danger in the feud and seeks a peaceful solution.

3. Furorotren. This is the kingdom of the free-spirited fairies who dwell among the ancient trees. ***Ober*** comes to visit ***Milan***, the intelligent sage of the forest and the leader of these mischievous fairies who distract ***Ober*** to another route to make him lose his way.

4. Morov, the hidden land. In the colony of ***Morov***, huge ears and bushy tails are the special features of the inhabitants. They speak in their own distinctive language, but have also recently mastered the language of the humans. ***Ticoro*** is a soft and fluffy ancient spirit.

5. Rebilim Waterfall. Mermaids live in the water kingdom underneath the water. They avoid having any relations with other races. ***Vina***, the mermaid who believes herself to be the most beautiful creature in the world, is the leader of the mermaids, and does not have good relations with the leader of the fairies, for she believes in her own values, which contradict the values of the fairies.

6. Volfolo Volcano, This is the land of the proud dragons. The leader's child, ***Fego***, claims the right to power, but he is mocked for being a coward. With ***Ober***'s encouragement, ***Fego*** has decided to become a splendid leader who can unite the dragon race.

Activating the Characters

Characters are activated, and the story is built. When the characters are entangled in a story, each of their individualities is developed and enhanced.

Storyboard for the Vampire Story

Karuki, a vampire, and Lucia, a beautiful maiden of the forest meet and fall in love. Suddenly, a jealous snake who can transform himself into a human, Naga, enters, and the three characters find themselves wrapped in a twist of love and fate, unfolding a sorrowful story.

Vampire x snake x reincarnation x young lady x maiden

Introduction of Karuki, a vampire

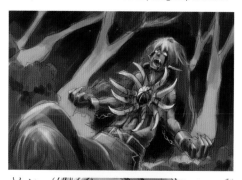

Encounter of Karuki and Lucia, a forest maiden

Incarnation of Naga, the snake

Naga tries to seduce Lucia.

Karuki and Naga meet.

Naga confronts Karuki.

Naga attacks Karuki.

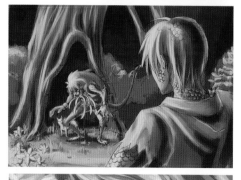

Karuki attacks back.

Character Setting for the Vampire Story

Karuki, a coward vampire

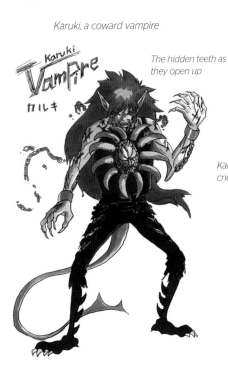

The hidden teeth as they open up

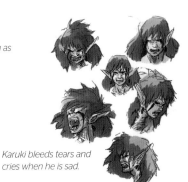

Karuki bleeds tears and cries when he is sad.

Lucia comes to the forest to collect flowers every morning.

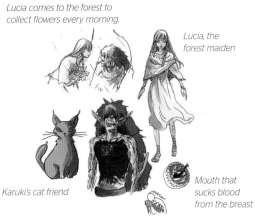

Lucia, the forest maiden

Karuki's cat friend

Mouth that sucks blood from the breast

Karuki sleeps in the hole of the tree.

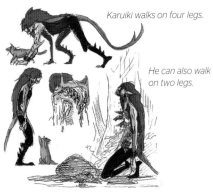

Karuiki walks on four legs.

He can also walk on two legs.

Incarnated Snake, Naga

The villagers worship the snake man as a god.

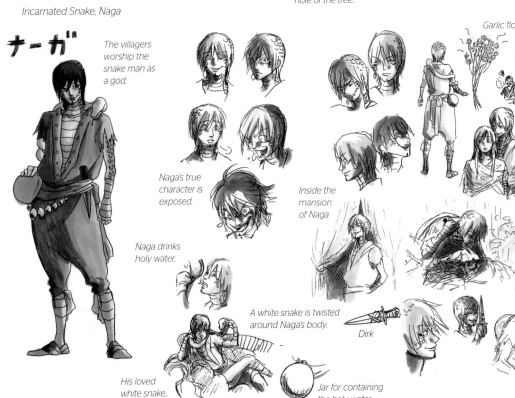

Naga's true character is exposed.

Naga drinks holy water.

A white snake is twisted around Naga's body.

His loved white snake..

Jar for containing the holy water

Inside the mansion of Naga

Dirk

Garlic flower

Anyone who eats the garlic flower would have garlic breath for two to three hours.

Naga pursues the forest maiden.

Naga feels pleasure in killing Karuki.

Karuki sucks blood from Naga and infects him with the blood-sucking power.

Super Manga Matrix + – ÷ ×

Using Attributes of Nature
Chapter 5

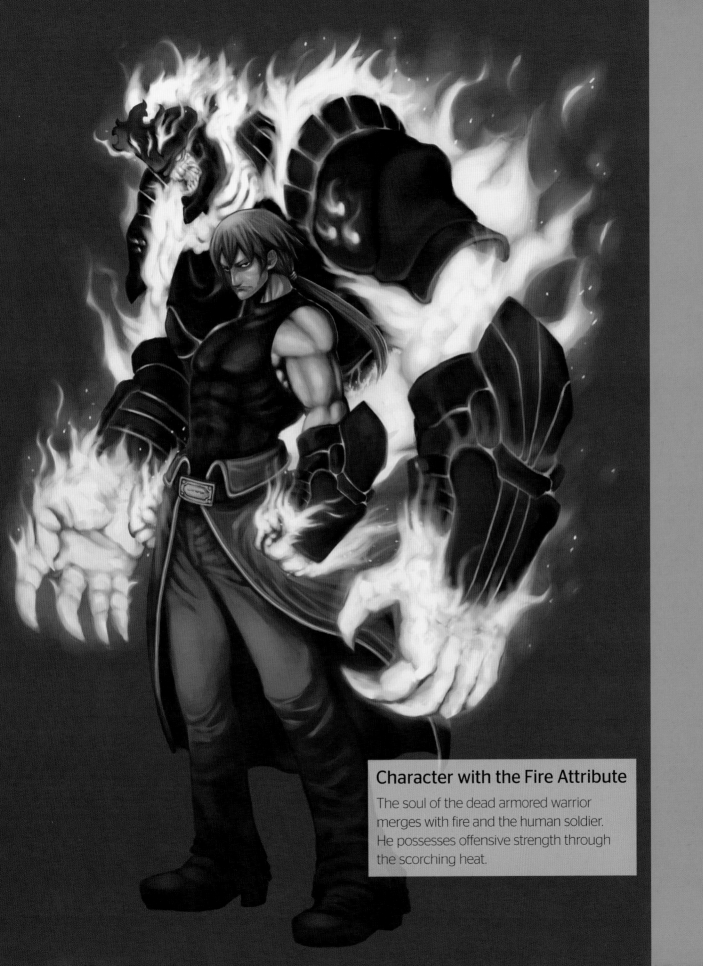

Character with the Fire Attribute

The soul of the dead armored warrior merges with fire and the human soldier. He possesses offensive strength through the scorching heat.

How to make characters using the attributes of nature

The four elements of nature (wind, fire, water, and earth) constitute the world, and create a new individualistic character when they are used as supplements in the Addition method.

Wind Attributes

The wind does not have a definite form, but is rather, a free element. In order to manifest free expression, this character emphasizes the effective use of its wings.

Character with windmill and wind chime

Winged character

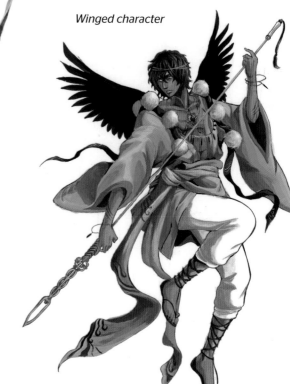

Feathered character

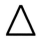

Fire Attributes

Fire expresses emotion and
shows an image of power.
It also consists of both light
and shadow. For instance,
in expressing a grudge
or affection, a character
with fire attributes uses its
strength and, at the same
time, its vanity.

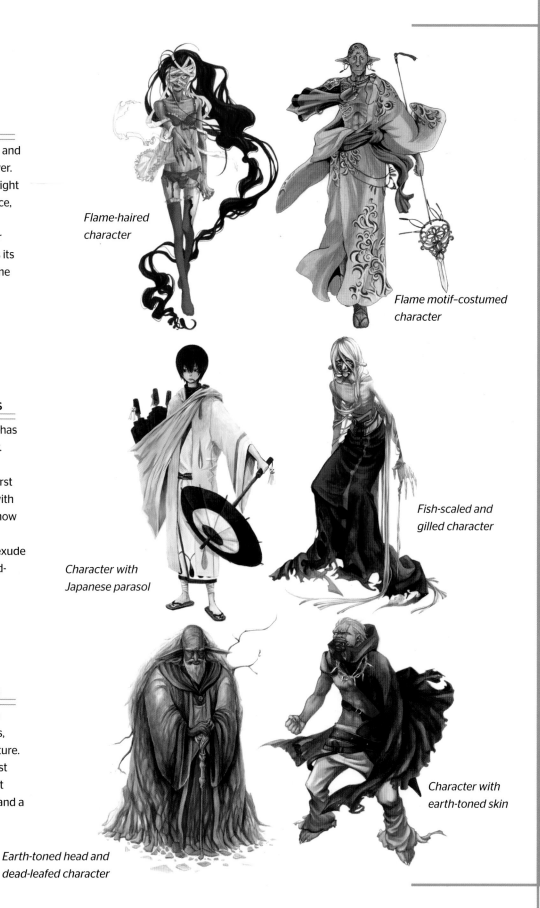

*Flame-haired
character*

*Flame motif–costumed
character*

Water Attributes

Water has no form, but has
an element of flexibility.
It can display a fearful
strength, like the outburst
of a flood. Characters with
water attributes may show
an image of clarity and
transparency, yet also exude
a subtle element of cold-
blooded fear.

*Character with
Japanese parasol*

*Fish-scaled and
gilled character*

Earth Attributes

The earth elements are
very crucial for humans,
plants, animals, and nature.
Characters that manifest
them are not gaudy, but
rather display warmth and a
powerful energy.

*Earth-toned head and
dead-leafed character*

*Character with
earth-toned skin*

wind attributes

Siren, the Wind Whisperer

The wind does not have a form or color, but rather is characterized by sound. Hence, this character, Siren, is accentuated with a horn to produce a sound and is adorned by four wings around his body.

風 – wind		Tool	horn
Character	easily cries	Power	uses the wind
Form	fairy	Sex	neutral
Function	carries seeds	Design	wings

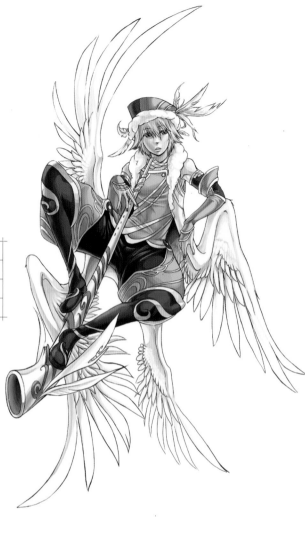

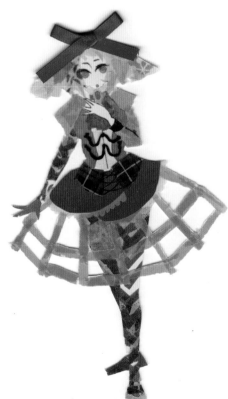

Matoi, the Girl Wrapped in Wind

Matoi likes senseless lies. Her body is wrapped by a blowing, quiet wind where no heart can enter. Also, no one can catch her.

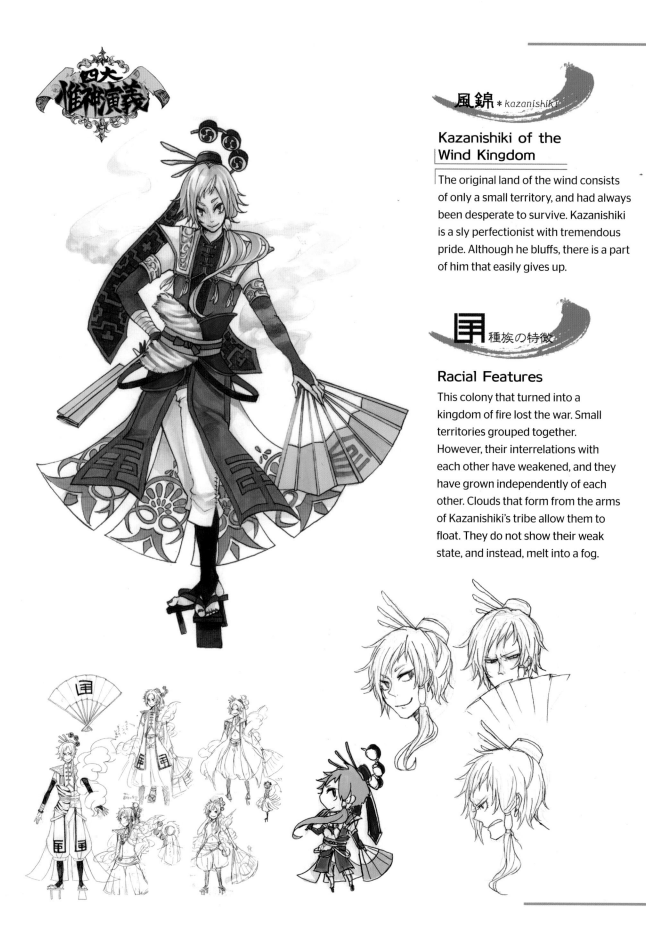

四大　惟神演義

風錦 ＊ *kazanishiki*

Kazanishiki of the Wind Kingdom

The original land of the wind consists of only a small territory, and had always been desperate to survive. Kazanishiki is a sly perfectionist with tremendous pride. Although he bluffs, there is a part of him that easily gives up.

�界 種族の特徴

Racial Features

This colony that turned into a kingdom of fire lost the war. Small territories grouped together. However, their interrelations with each other have weakened, and they have grown independently of each other. Clouds that form from the arms of Kazanishiki's tribe allow them to float. They do not show their weak state, and instead, melt into a fog.

fire attributes
火属性

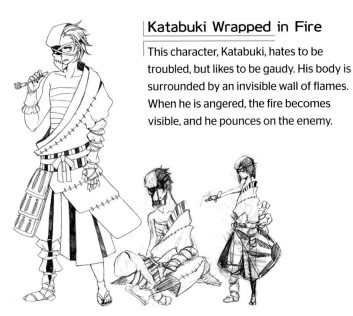

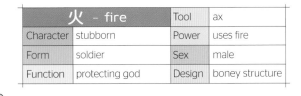

火 – fire		Tool	ax
Character	stubborn	Power	uses fire
Form	soldier	Sex	male
Function	protecting god	Design	boney structure

Zazi, the Flame Whisperer

Fire extinguishes all elements, but it also has the power to give birth to a new life. By using axes in both hands, Zazi can manipulate fire freely. He is a god protector, but he uses his flame-iron axes to perform merciless deeds toward evil people.

Katabuki Wrapped in Fire

This character, Katabuki, hates to be troubled, but likes to be gaudy. His body is surrounded by an invisible wall of flames. When he is angered, the fire becomes visible, and he pounces on the enemy.

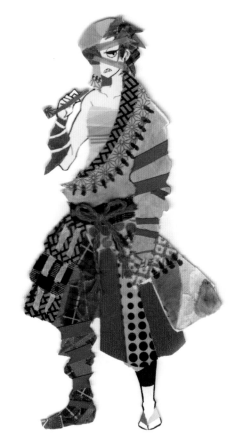

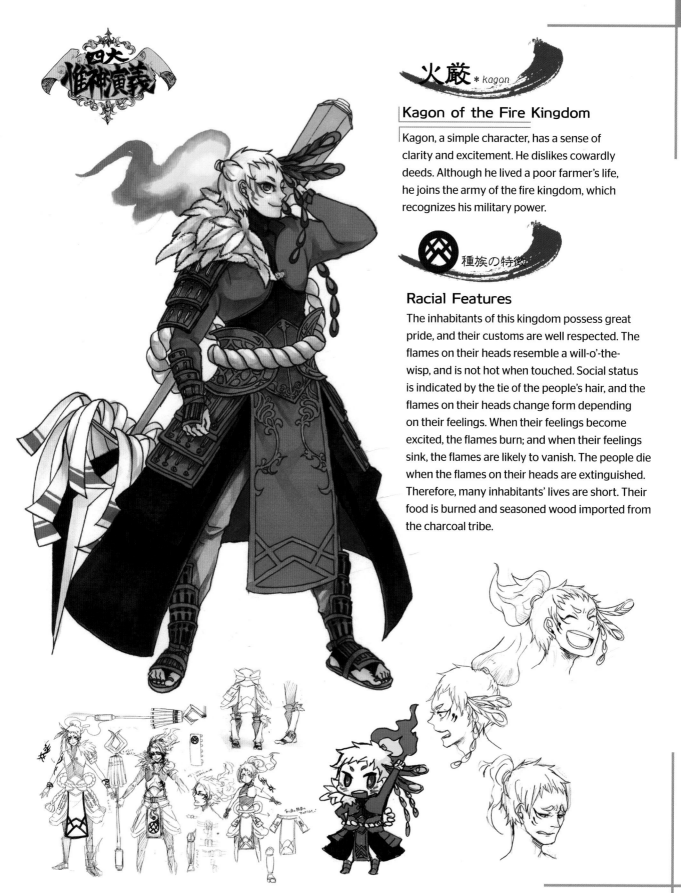

火厳 * kagon

Kagon of the Fire Kingdom

Kagon, a simple character, has a sense of clarity and excitement. He dislikes cowardly deeds. Although he lived a poor farmer's life, he joins the army of the fire kingdom, which recognizes his military power.

種族の特徴

Racial Features

The inhabitants of this kingdom possess great pride, and their customs are well respected. The flames on their heads resemble a will-o'-the-wisp, and is not hot when touched. Social status is indicated by the tie of the people's hair, and the flames on their heads change form depending on their feelings. When their feelings become excited, the flames burn; and when their feelings sink, the flames are likely to vanish. The people die when the flames on their heads are extinguished. Therefore, many inhabitants' lives are short. Their food is burned and seasoned wood imported from the charcoal tribe.

Chapter 5

water attributes

水属性

水 - water		Tool	chained weapon
Character	cruel	Power	manipulates water
Form	noble class	Sex	male
Function	protects the river	Design	ice structure

Rei, the Water Whisperer

Water makes all things pure. It has the power to nurture life, but once it is angered, it uses its power to threaten life. Anything that touches the ice weapon freezes.

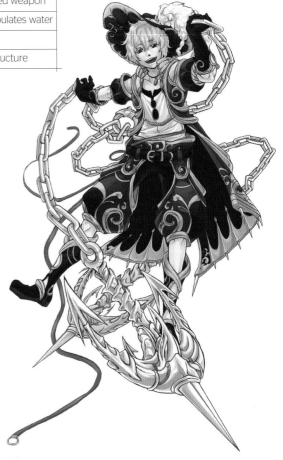

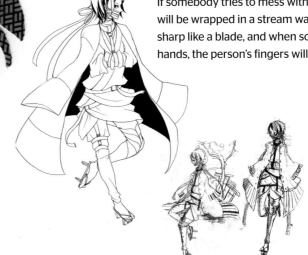

Baku Wrapped in Water

Baku does not like to speak nor be involved with anything. Hence, he covers his mouth with a mask. He has a compulsive sense for cleanliness. If somebody tries to mess with Baku, Baku's body will be wrapped in a stream wall. The stream is sharp like a blade, and when someone touches his hands, the person's fingers will fall off.

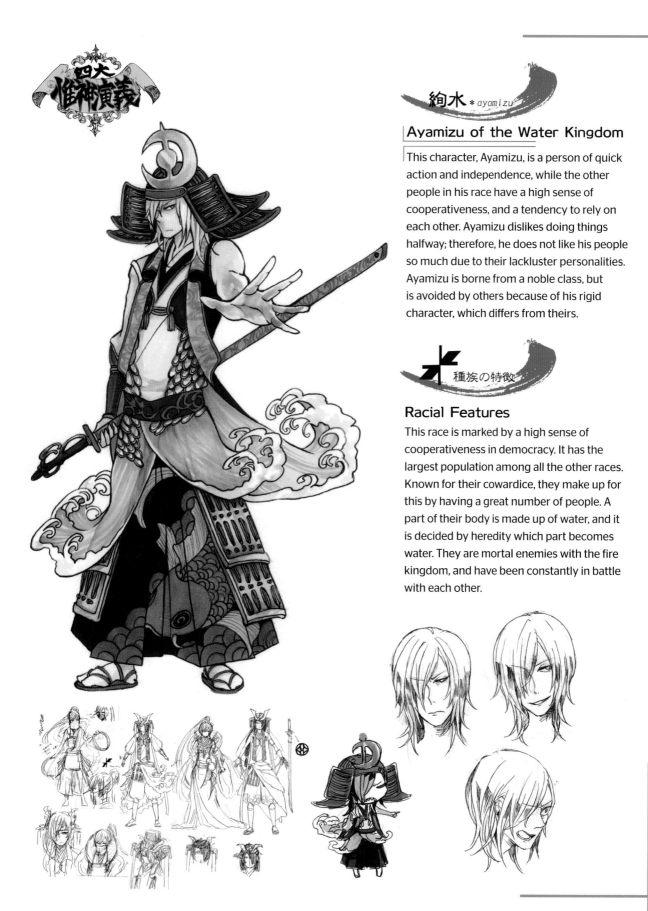

Ayamizu of the Water Kingdom

絢水 *ayamizu

This character, Ayamizu, is a person of quick action and independence, while the other people in his race have a high sense of cooperativeness, and a tendency to rely on each other. Ayamizu dislikes doing things halfway; therefore, he does not like his people so much due to their lackluster personalities. Ayamizu is borne from a noble class, but is avoided by others because of his rigid character, which differs from theirs.

種族の特徴

Racial Features

This race is marked by a high sense of cooperativeness in democracy. It has the largest population among all the other races. Known for their cowardice, they make up for this by having a great number of people. A part of their body is made up of water, and it is decided by heredity which part becomes water. They are mortal enemies with the fire kingdom, and have been constantly in battle with each other.

earth attributes

土属性

Jun, the Earth Whisperer

All living things live with the earth, and return to the earth. This character, Jun, is blessed with strong tenderness, and is a god protector who guards life. By playing the mandolin, he is able to wipe off the dirt from people's souls, and can calm them down.

土 – earth		Tool	mandolin
Character	easily falls in love	Power	nurtures life
Form	minstrel	Sex	male
Function	god protector	Design	tree trunk

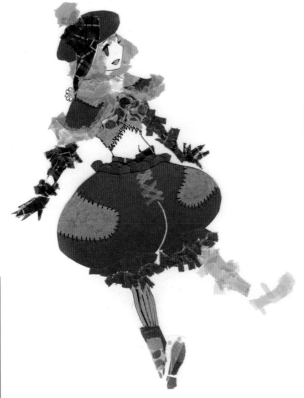

Kimi, the Girl Wrapped in Earth

Kimi has a gentle character, and has the natural innocence of a fool. She likes to look at the sky all day, and is well liked by everyone. Her body is wrapped by the invisible earth, which smells like the sun.

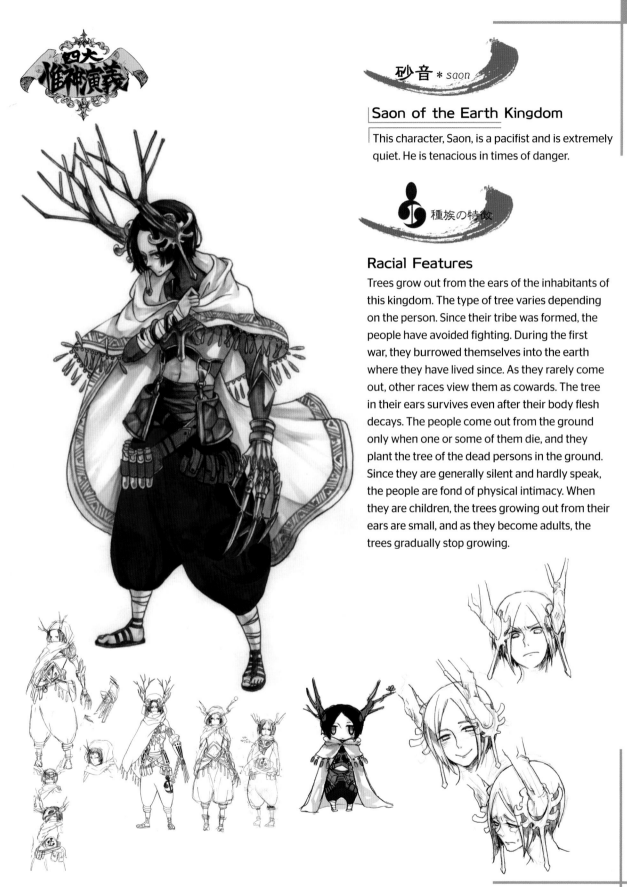

砂音 * saon

Saon of the Earth Kingdom

This character, Saon, is a pacifist and is extremely quiet. He is tenacious in times of danger.

種族の特徴

Racial Features

Trees grow out from the ears of the inhabitants of this kingdom. The type of tree varies depending on the person. Since their tribe was formed, the people have avoided fighting. During the first war, they burrowed themselves into the earth where they have lived since. As they rarely come out, other races view them as cowards. The tree in their ears survives even after their body flesh decays. The people come out from the ground only when one or some of them die, and they plant the tree of the dead persons in the ground. Since they are generally silent and hardly speak, the people are fond of physical intimacy. When they are children, the trees growing out from their ears are small, and as they become adults, the trees gradually stop growing.

Personification

Chapter 6

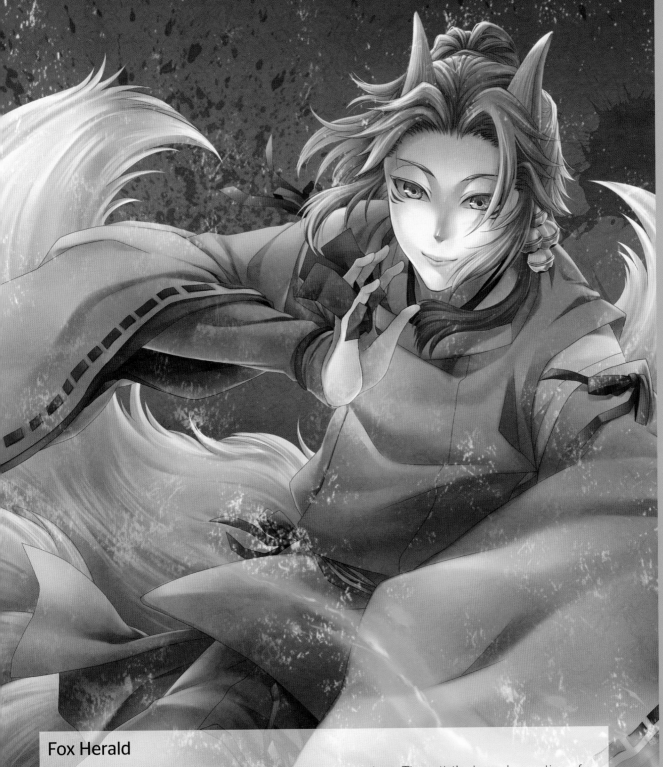

Fox Herald

The basic foundation of the Personification technique is love. The artist's close observation of the objects and characters allows him to develop affection towards them, which makes them transform into humans or exhibit human-like emotions. The nine-tailed fox is an incarnated and auspicious animal that is said to live for many years. It is a godly beast that brings trouble to people and admonishes them. By gazing closely at a fox, one develops a special feeling of love for it, and the fox turns into a human being. This character expresses such a transformation.

How to make characters using the Personification technique

Seen in many novels, the personification technique makes objects and other nonhuman elements appear human-like. Objects adopt human feelings and communicative ability, and they express their own individuality.

In the right image, the piece of cake is turned into a human character.

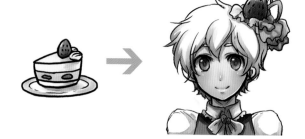

Fox Personification

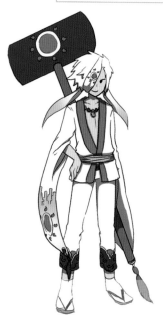

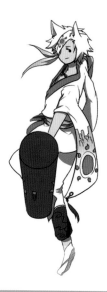

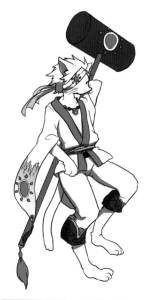

Full Human Personification

This character consists of a totally human form. It shows a human expression and an easygoing nature.

Beast Personification (Human-like)

This popular form of personification is one of the easiest figures to create. It consists of a human plus a prototype—in this case, a fox.

Beast Personification (Beast-like)

This character resembles a human form, but still retains beast-like features in its skin, hair, hands, and feet.

Full Beast Personification

Though not a very popular form of personification, it applies the technique of allowing the character to speak like a human, but to act completely like a beast.

Forms of Personification by Machine, Nature, Food, and Animal

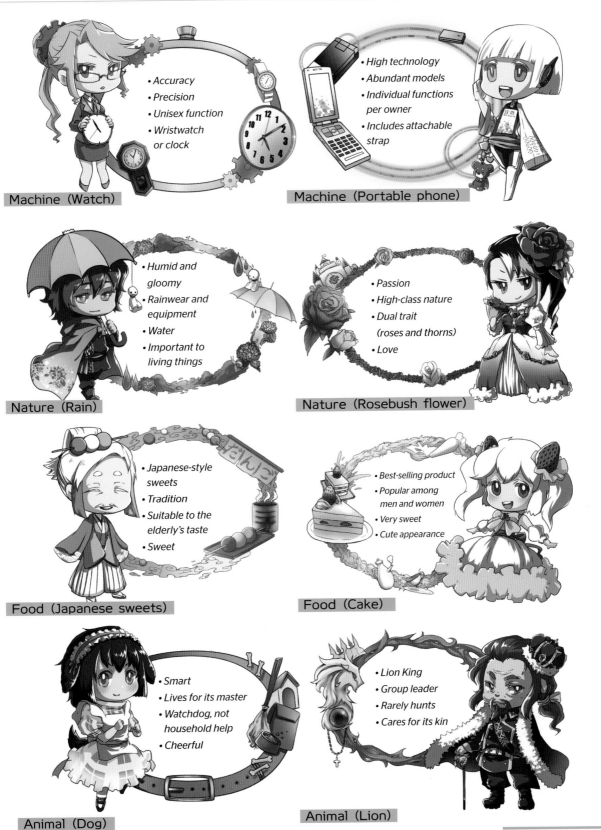

Machine (Watch)
- Accuracy
- Precision
- Unisex function
- Wristwatch or clock

Machine (Portable phone)
- High technology
- Abundant models
- Individual functions per owner
- Includes attachable strap

Nature (Rain)
- Humid and gloomy
- Rainwear and equipment
- Water
- Important to living things

Nature (Rosebush flower)
- Passion
- High-class nature
- Dual trait (roses and thorns)
- Love

Food (Japanese sweets)
- Japanese-style sweets
- Tradition
- Suitable to the elderly's taste
- Sweet

Food (Cake)
- Best-selling product
- Popular among men and women
- Very sweet
- Cute appearance

Animal (Dog)
- Smart
- Lives for its master
- Watchdog, not household help
- Cheerful

Animal (Lion)
- Lion King
- Group leader
- Rarely hunts
- Cares for its kin

Chapter 6

jewels

宝石

Jewel Personification

Throughout history, jewels have charmed humans. They depict all kinds of expressions: light, form, color, warmth, coldness, and brightness. What types of characters can be created from jewels?

Sapphire

Sapphire is the King of Jewels and is paired with Ruby. He symbolizes trust, hope, and destiny. He is a king who enjoys the confidence of his people. He is overcautious and prudent. Since he is quite intelligent, he does not have much muscular strength. He is thin, and is twenty-five years old.

Emerald

Compared with other jewels, Emerald is quite soft; therefore, she is susceptible to many flaws. Her character symbolizes happiness and conjugal love. She is a lady's maid, who takes care of the royal family. She is gentle, but is very hardworking. She is much loved by the head of the family. Her wounds remain fresh. She is seventeen years old, but remains childlike.

Ruby

Ruby is the Queen of Jewels and is paired with Sapphire. She is a very passionate queen, and likes roses, which have the same meaning as her name. She is around thirty years old.

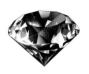

Diamond

Diamond consists of the hardest substance among all the gemstones. Her character is created from an image of a dauntless girl who cannot be conquered, and who refrains from familiarity. She is pure, and preserves eternal ties.

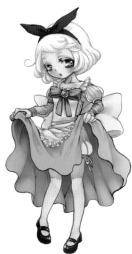

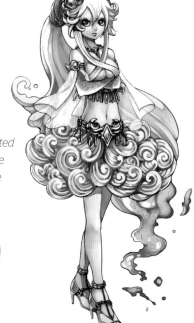

Aquamarine

This character is created from the image of the sea. She is passionate and courageous.

Turquoise

Turquoise ranges from blue to green. It has been used as an ornament for thousands of years. The Turquoise character in this image represents a long-lasting race, similar to the Native Americans.

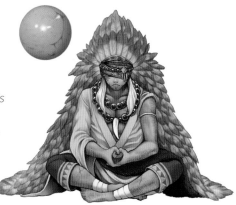

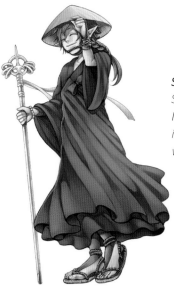

Tourmaline

Tourmaline consists of two to three colors, and possesses the strength of a power stone. Tourmaline's character in this image is pictured as a fairy that lives in the forest.

Sugilite

Sugilite is known as a power stone. It is colored purple, with a holy image. His character is associated with a travelling monk.

flowers

花

Flower Personification

Flowers are loved by everyone, and are simple motifs to use for personification. It is also easy to associate characters with the language of flowers.

Rosemary

The language of this flower means "memory." In Latin, it means the drop of the sea. It symbolizes eternity, taken from the evergreen plant. Rosemary is used at both funerals and wedding ceremonies. It also signifies philanthropy. Her character is created from an image of a slender bride or a nun.

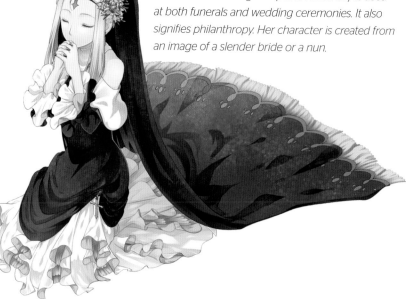

Jasmine

The language of Jasmine means "mildness," "charm," and "being followed." In India, women braid their hair with jasmine taken from their lovers; hence, this flower is considered a proof of love. This character is a woman who is mild, kind, and who likes tea and belly dancing.

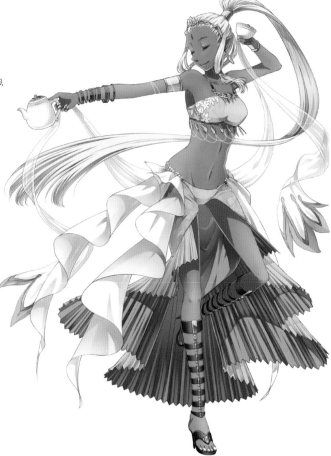

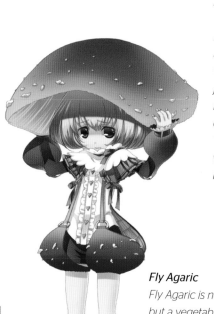

Fly Agaric

Fly Agaric is not actually a flower, but a vegetable species. It is a poisonous mushroom with a low toxic level. It symbolizes happiness, and often appears in children's stories. This character is created with a slightly evil personality, but without a sense of guilt.

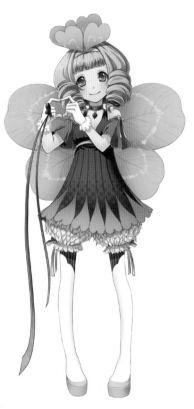

Camellia

The language of Camellia signifies "the highest beauty." This image of dignity and grace depicts a character of a refined European lady. She is a queen of the high society.

Clover

The language of this flower means, "Please remember me," or "promise." The three-leaf clover, or honewort, signifies love, hope, and faith; while the four-leaf clover symbolizes happiness. The girl in this image is created with a positive personality. She likes making promises by hooking her little fingers.

Bird of Paradise

The language of this flower means "love struck," "tolerance," and "pompous love." From this image, this flashy and cheerful playboy character is created. Since he grew up in a southern country, he is sensitive to the cold.

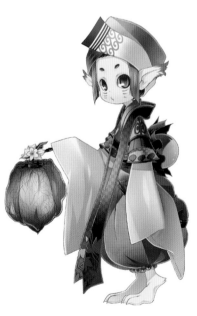

Ground Cherry

The language of the Ground Cherry means "lie" or "deception." Small lanterns that children make out of red paper pasted together are called "ground cherry lanterns." An image of a feeble-looking eight-year-old boy is created.

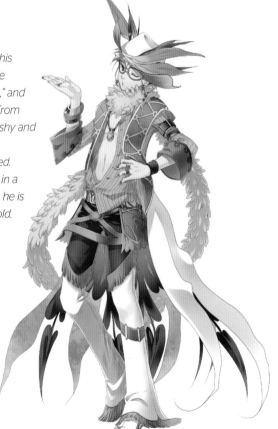

sweets
お菓子

Sweets Personification

Sweets give a pleasant sensation to the mouth. They are loved by everyone, and so are characters who are personified from them.

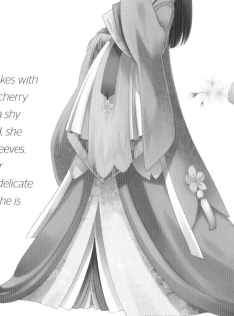

Sakura Mochi

Sakura mochi *are Japanese rice cakes with bean paste wrapped in preserved cherry blossoms leaves. This character is a shy princess. When she is embarrassed, she covers her face with her kimono sleeves. She likes to wear one garment over another. She has a dreamy look, a delicate physique, and is poor in athletics. She is sixteen years old.*

Nerikiri

Nerikiri *literally means kneading, and is a type of Japanese unbaked cake. This character is an artist who is familiar with sculptures and paintings. He has a spirit of a true artisan. He is very handy with tools, and is always equipped with pallets, paint brushes, and a pair of scissors. He has a large body, but creates many adorable objects. He is about twenty-eight years old.*

Cream Anmitsu

Anmitsu *is a Japanese dessert made of sweet agar jelly, boiled peas, and red bean paste. This character depicts a typical Japanese Edo-era girl. She likes to take good care of people, and she acts like an elder sister to the children in the neighborhood. She may not be studious, but she is very athletic, and is a perfect housekeeper. She is fourteen years old.*

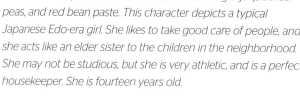

fingers

指

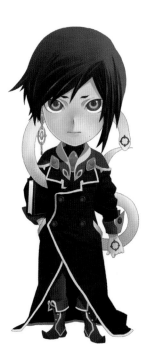

Finger Personification

When the five fingers of a hand are personified, a role-playing game is developed, like a party for five people.

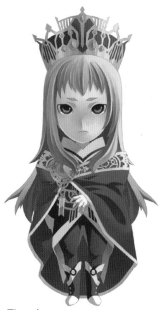

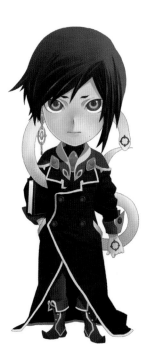

Thumb

This character is a personification of the thumb. Without the thumb, we cannot hold anything. He is an absolutely indispensable prince.

Index Finger

This character is a personification of the index finger. He possesses a strong sense of justice and courage. He is a knight who fully protects his loved ones.

Middle Finger

The personified image of the middle finger shows a bold and tough character. He is a very mysterious and tactical monk.

Ring Finger

The ring finger is also known as the medicine finger in Japan, as it is used by the Japanese to apply medicines. She is a kind white mage who values her friends.

Pinky Finger

This personified image of the little finger is small and cute. She resembles a mascot at a party..

Super Manga Matrix + − ÷ ×

Chapter 6

Personification

animals

動物

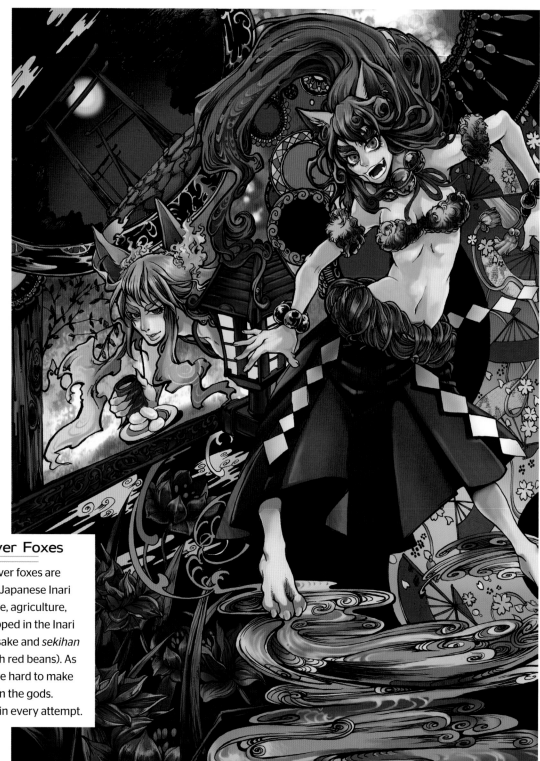

Gold and Silver Foxes

These gold and silver foxes are personified as the Japanese Inari gods of fertility, rice, agriculture, and foxes, worshipped in the Inari Shrine. They love sake and *sekihan* (red sticky rice with red beans). As humans, they strive hard to make everyone believe in the gods. However, they fail in every attempt.

antique objects

道具

Personification of Antique Objects

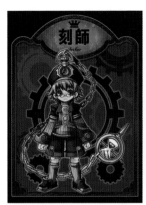

Clock Checker

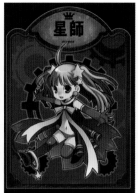

Star Wizard

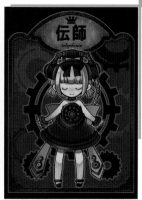

Traditionalist

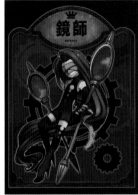

Mirror Woman

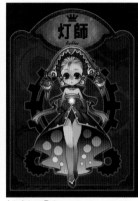

Lighter Princess

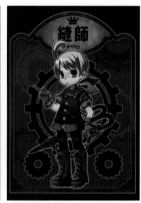

Sewing Master

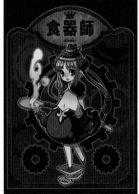

Dishwasher

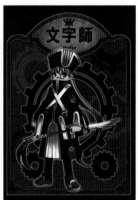

Man of Letters

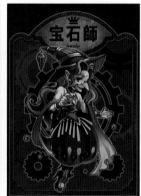

Jeweler

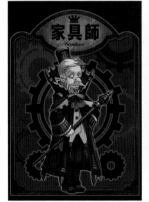

Furniture Maker

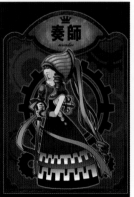

Sound Mistress

Bottle Girl

Super Manga Matrix + - ÷ ×

The 1-2-3-4-7 Technique

Chapter 7

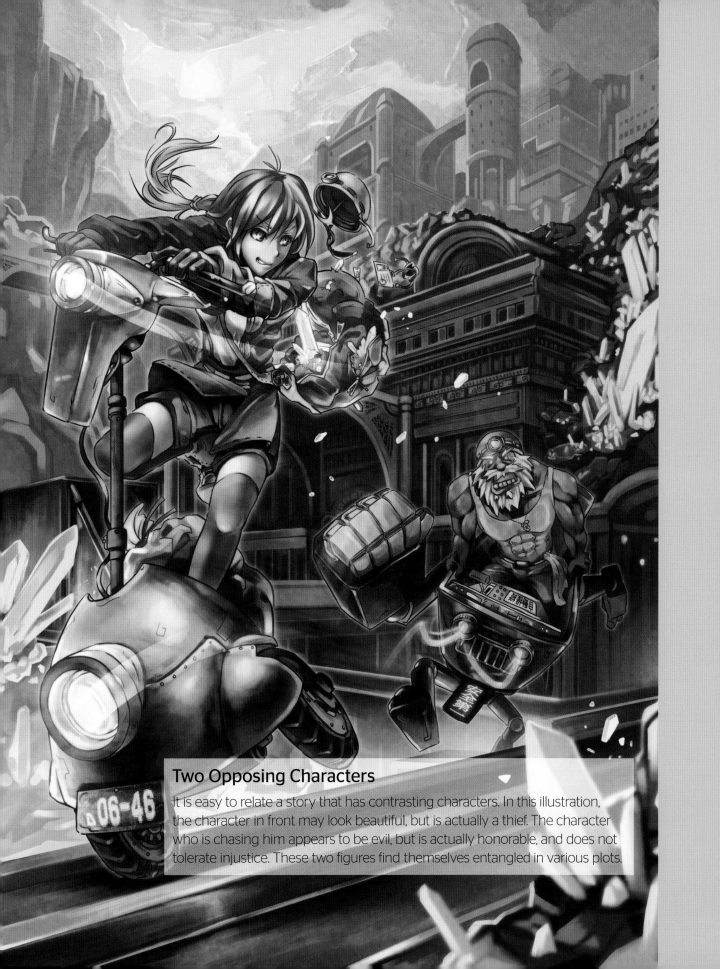

Two Opposing Characters

It is easy to relate a story that has contrasting characters. In this illustration, the character in front may look beautiful, but is actually a thief. The character who is chasing him appears to be evil, but is actually honorable, and does not tolerate injustice. These two figures find themselves entangled in various plots.

How to make characters using the 1-2-3-4-7 technique

The 1-2-3-4-7 technique begins with one story that evolves around many varied main characters. Depending on the number of characters, the characters' roles change and define the story plot.

Method 1: The Main Character

By setting the main character, a storyline can be conceptualized. The story may be based on an old tale, mythology, or fable, wherein the hero becomes the most attractive element in the plot.

Main character

The hero or heroine is the most attractive character

Method 2: Two Opposing Characters

In any storyline, the main character does not stand alone. He or she is accompanied by two more characters that display opposing personalities: good and evil; shadow and light; or angel and devil. These opposing images create the drama in the plot.

Opposing characters

Diligent and nondiligent characters

Method 3: Emotion, Action, Knowledge

Just like the three major characters Tin Man, Cowardly Lion, and Scarecrow in the famous tale *The Wizard of Oz*, manga and games also often evolve around three individual characters. One character is usually sensitive and emotional; another is active; and the other is wise.

Three Characters

(Tin Man)

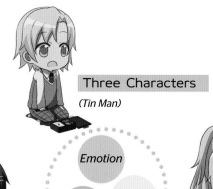

Emotion

Action

Knowledge

(Cowardly Lion)

(Scarecrow)

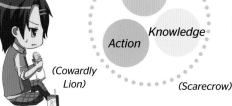

Method 4:
Method 3 + Yin (Dark) or Yang (Light)

A story with four characters may use the method for three characters and add the elements of Yin ("Dark" character representing the group leader) or Yang ("Light" character representing the possible leading role in the group). For example, in *The Wizard of Oz*, Dorothy joins the three characters Tin Man, Scarecrow, and the Cowardly Lion. Dorothy represents "light," and becomes the heroine of the story. Conversely, the fourth character can also represent "dark," which is commonly used in Eastern cultures. In this case, the character of "emotion" would play the lead role in the story.

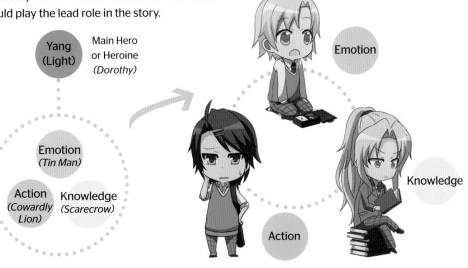

Yang
(Light)

Main Hero or
Heroine

Four-character
Group

Emotion

Knowledge

Action

Yang
(Light)

Main Hero
or Heroine
(Dorothy)

Emotion
(Tin Man)

Action
*(Cowardly
Lion)*

Knowledge
(Scarecrow)

Method 7:
Combination of Various Personalities

The seventh method incorporates seven or more characters with strong personalities that may clash but mutually respect each other. A story may consist of five, six, eight or more characters as long as they have separate individual traits, although having seven characters provides the best balance, charm and dramatic effect. A good example is the popular story, *Snow White and the Seven Dwarfs*, which consists of the dwarf characters Grumpy, Doc, Happy, Sleepy, Bashful, Sneezy, and Dopey. Likewise, in the famous Japanese movie *The Seven Samurai*, and in the American movie *The Magnificent Seven*, the stories evolve around seven individual characters.

Seven Personalities

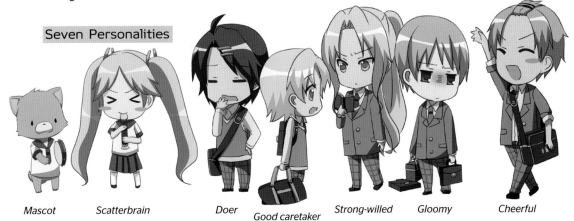

Mascot *Scatterbrain* *Doer* *Good caretaker* *Strong-willed* *Gloomy* *Cheerful*

method 1: the main character

1の手法

Absolute Heroes

At first, everyone draws heroic characters. When you imagine yourself as a hero, you can succeed in drawing such a character. Heroes promote justice, guard friends, stand by beliefs, and do not spare efforts.

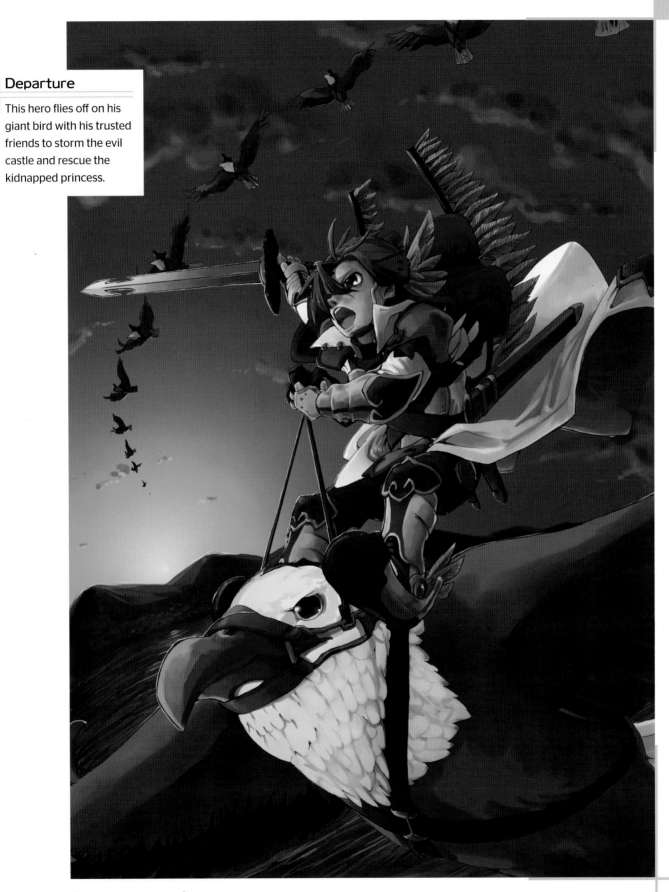

Departure

This hero flies off on his giant bird with his trusted friends to storm the evil castle and rescue the kidnapped princess.

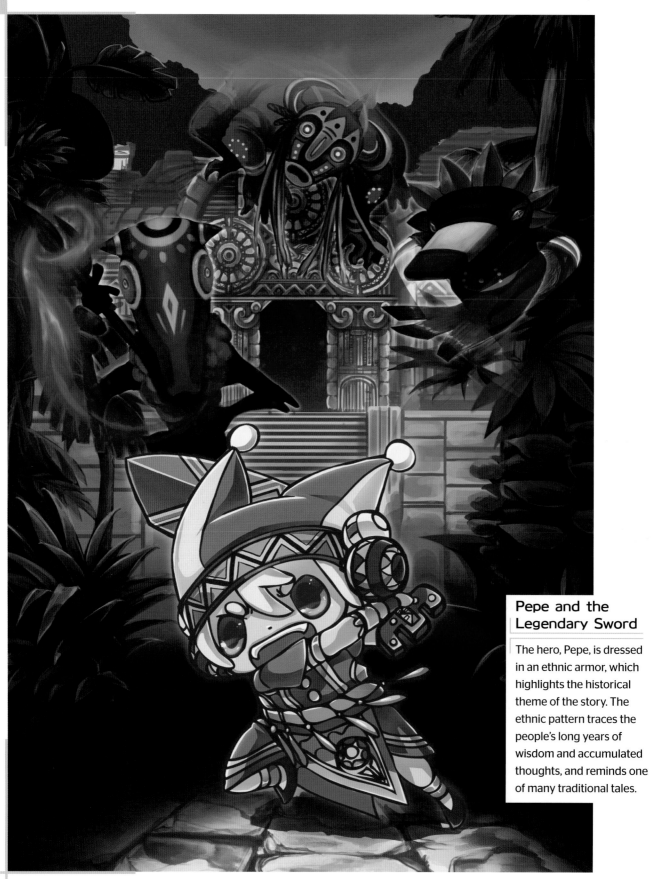

Pepe and the Legendary Sword

The hero, Pepe, is dressed in an ethnic armor, which highlights the historical theme of the story. The ethnic pattern traces the people's long years of wisdom and accumulated thoughts, and reminds one of many traditional tales.

Hero Before an Awakening

The typical figure of a hero before he awakens is a fainthearted boy. On the inside, he is a kind and gentle soul.

White Magician

This queen is a heroine who is naturally loved by all animals and also uses white magic.

method 2: two opposing characters

２の手法

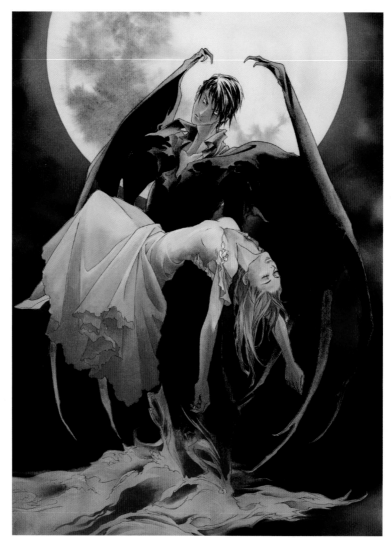

The Woman and the Vampire
A powerful, immortal man catches sight of an aging woman whom he falls in love with. By sucking the woman's blood, he changes her race to his. This act against natural providence triggers another tragedy.

Creating Contrasting Characters

Contrast is a basic element in character creation. A story with only one character would be dull. Without an element of comparison, a character's personality cannot be appreciated.

Love Between an Angel and a Devil
A playful devil falls in love with an angel, and a love comedy of laughter and tears is developed.

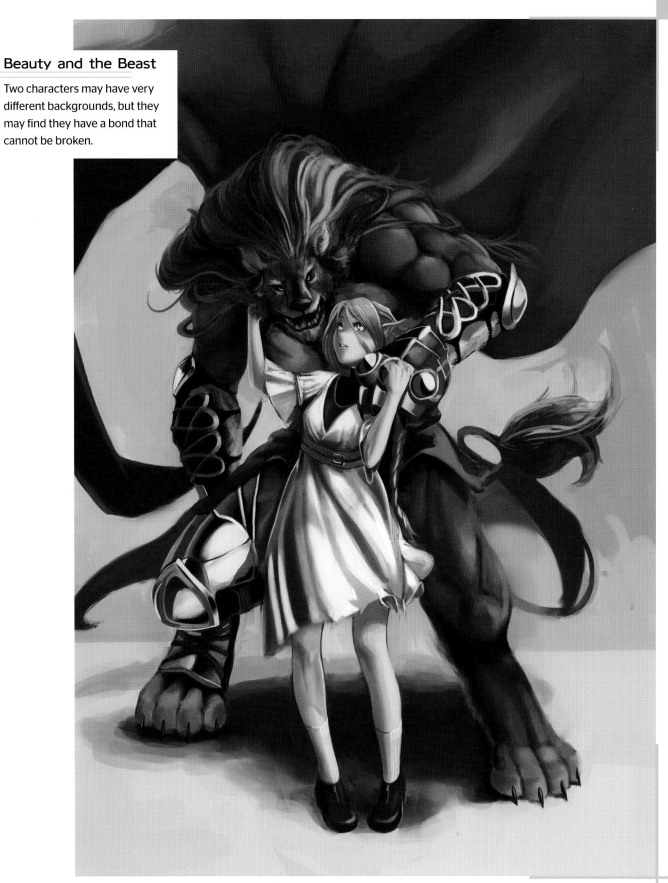

Beauty and the Beast

Two characters may have very different backgrounds, but they may find they have a bond that cannot be broken.

Two Ghost Demon Hunters

As much as possible, two characters should show contrast for a more effective impact—man and woman, old and young, animal and human, beautiful and ugly, protagonist and antagonist, and so on. The two ghost demon hunters in this illustration show contrast in their sex, appearance, and chosen weapons.

These two ghost demon hunters are also professional treasure hunters.

Hero and Heroine Crossing their Swords

This picture illustrates a white female soldier and a black male soldier. Exemplifying the method of using contrast, these two characters feel a strong friendship between them, but cannot avoid their fate of being forced into battle. Their relationship also affects other people's lives, they have faith that one day they can live together.

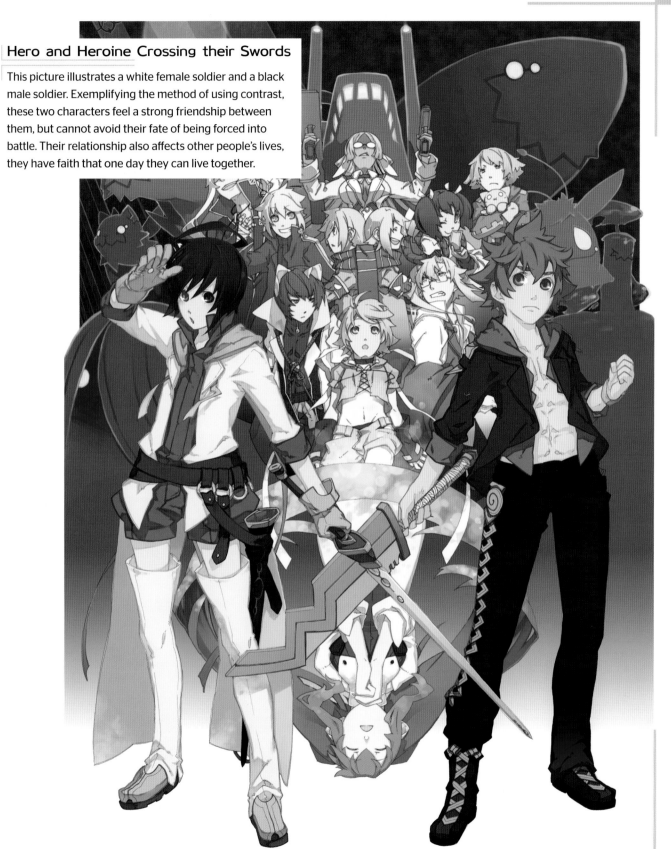

The 1-2-3-4-7 Technique

method 3: emotion, action, knowledge

3の手法

With the combination of three characters possessing emotion, action, and knowledge, the story begins to unfold, just like Luke, Han Solo, and Leia of Star Wars; and Harry, Ron, and Hermione of Harry Potter.

Jiraiya

This character is an homage to Jiraiya, a fictitious thief who appeared late in the Japanese Edo era. He is also a ninja who uses toad magic. Jiraiya is a childhood friend of Daijamaru and Mina.

Daijamaru

Daijamaru is both a rival and friend of Jiraiya. He uses snake magic. He has liked Mina since childhood, but he missed the chance to confess his feelings to her.

Three-way Ninja Fighters

Based on an old Japanese historical belief, the snake is strong against the frog; the frog is strong against the slug; and the slug is strong against the snake. As they compete with each other's strengths, a three-way standoff begins.

Mina

Mina uses slug magic. Her role is to support Jiraiya and Daijamaru. She has a cool appearance and a kind heart.

Hidden Ninja Trio

These three ninja characters possess different powers of nature and can turn themselves into their own weapons. Normally, they act independent of each other, but when they gather together, their personalities unite and release great power to overthrow the enemy.

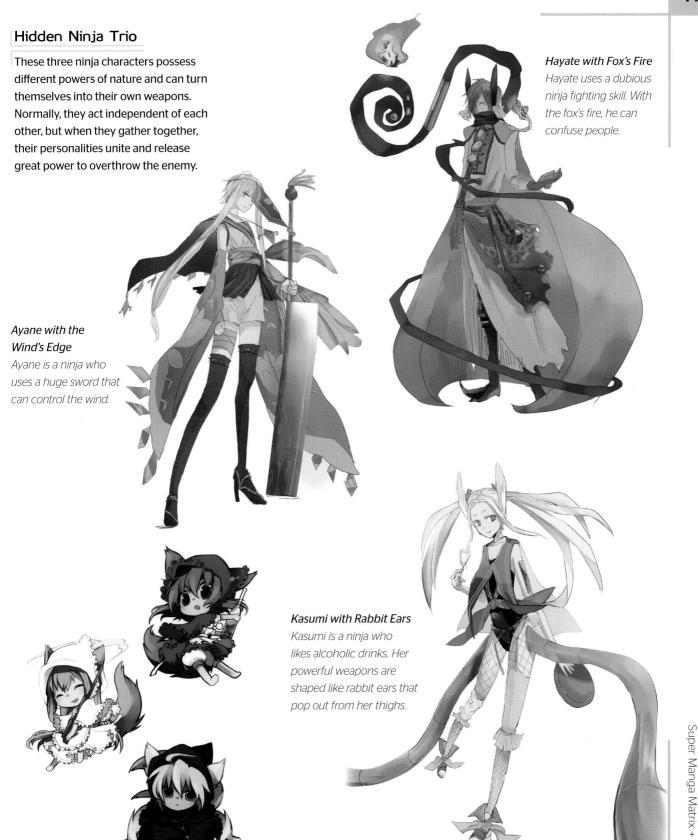

Hayate with Fox's Fire
Hayate uses a dubious ninja fighting skill. With the fox's fire, he can confuse people.

Ayane with the Wind's Edge
Ayane is a ninja who uses a huge sword that can control the wind.

Kasumi with Rabbit Ears
Kasumi is a ninja who likes alcoholic drinks. Her powerful weapons are shaped like rabbit ears that pop out from her thighs.

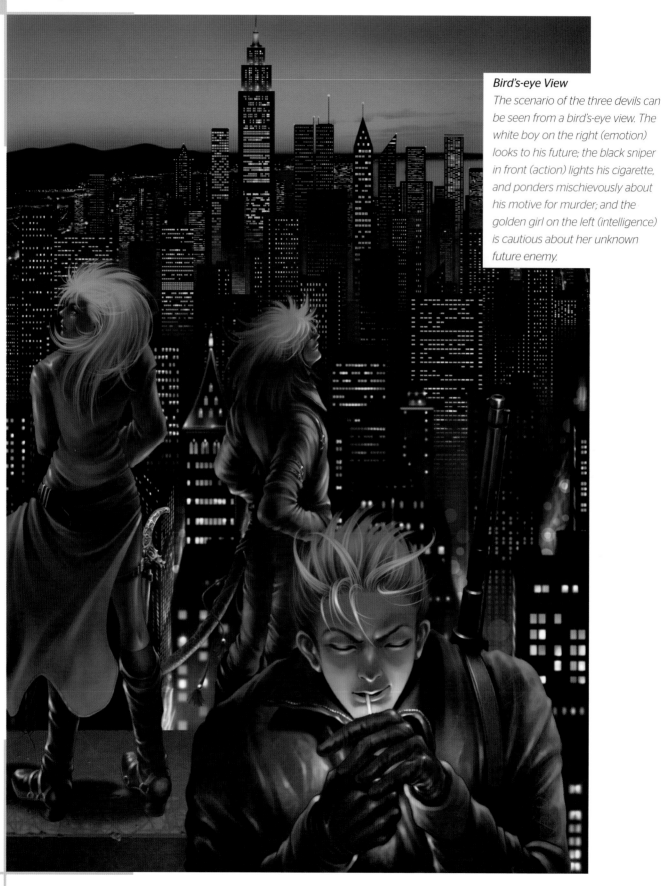

Bird's-eye View
The scenario of the three devils can be seen from a bird's-eye view. The white boy on the right (emotion) looks to his future; the black sniper in front (action) lights his cigarette, and ponders mischievously about his motive for murder; and the golden girl on the left (intelligence) is cautious about her unknown future enemy.

Three Skyscraper Devils

Three dark heroes live above this city's skyscrapers. Each of them possesses white (emotion), black (action), and gold (knowledge) powers. As they engage in battle, they try to search for the traditional, sacred books called White Book, Black Book, and Golden Book. As individuals, they may not be able to conquer the enemy, but if the three heroes unite, they can combine their white, black, and gold powers and win.

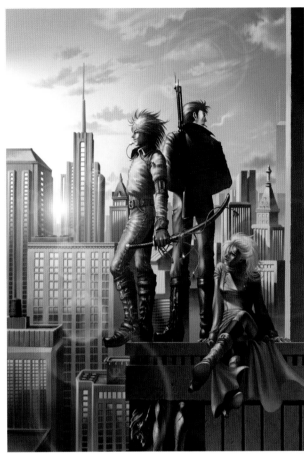

Eye level

By placing the camera in the same viewpoint as the three devils, the illustration highlights their different characteristics as though they appear in a documentary scene. The white boy (emotion) on the left is the main character, and has a strong will and sense of justice. The black sniper (action) in the center is cool, and has a nihilistic personality. The golden girl (intelligence) on the right is very intellectual and witty, and is the idol of the team.

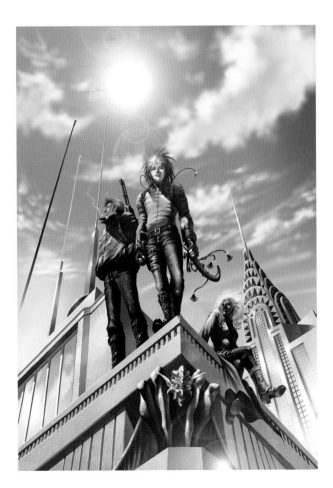

Worm's-eye View

This is an elevated composition as seen from the worm's-eye view. By using this perspective, the three characters' weapons can be clearly recognized. The white boy (emotion) in the center holds a sword; the black sniper (action) on the left is quiet, but strong, and carries a gun; and the golden girl (intelligence) on the right who uses her intelligence and knowledge, has a mysterious key-shaped short sword under her leg.

method 4:
method 3
+ yin
(dark) or
yang (light)

4 の 手法

Journey In Search of Oneself

The traveler, crow, and lion help find Fumi, who is lost. They continue their journey to take Fumi back to her home. None of them have particularly special abilities, but by combining their skills, they are able to solve their problems. As a result, both Fumi and the three characters find their own ways.

In addition to the elements of emotion, action, and knowledge used in Method 3, another character representing Yin (dark) or Yang (light) completes the fourth method. With four characters, the story creates a very powerful team.

The lost child, Fumi

The traveler as a knowledgeable philosopher

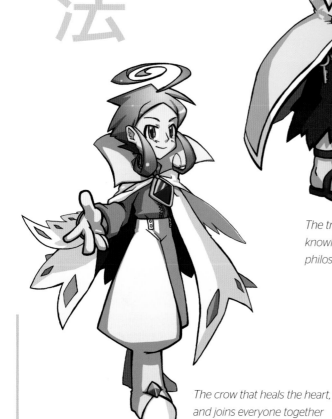

The courageous lion

The crow that heals the heart, and joins everyone together

Conspicuous Characters

These characters' individual personalities are specific and unique to allow them to function alone. When combined, they gain enormous power.

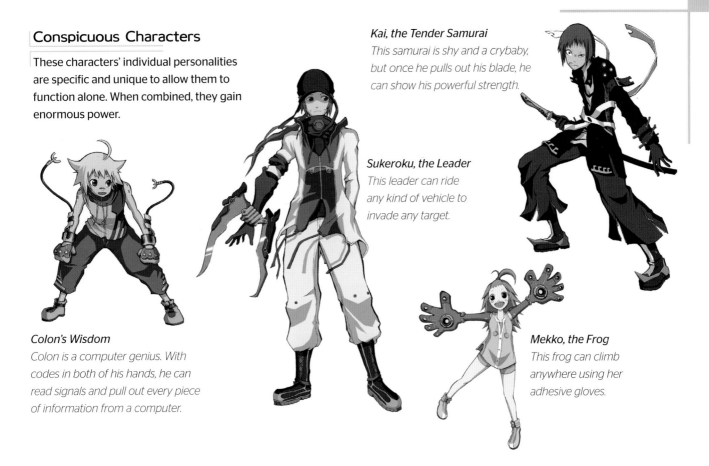

Kai, the Tender Samurai
This samurai is shy and a crybaby, but once he pulls out his blade, he can show his powerful strength.

Sukeroku, the Leader
This leader can ride any kind of vehicle to invade any target.

Colon's Wisdom
Colon is a computer genius. With codes in both of his hands, he can read signals and pull out every piece of information from a computer.

Mekko, the Frog
This frog can climb anywhere using her adhesive gloves.

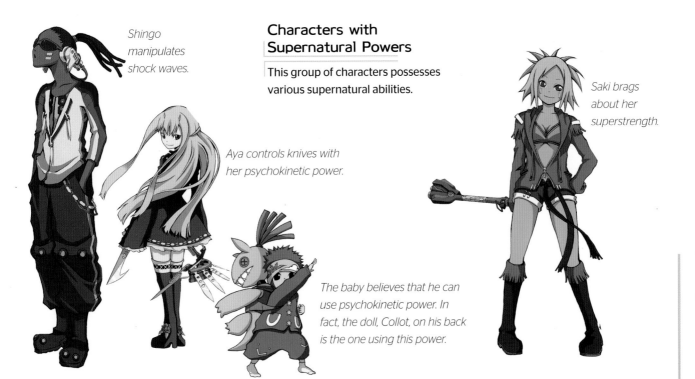

Shingo manipulates shock waves.

Characters with Supernatural Powers

This group of characters possesses various supernatural abilities.

Aya controls knives with her psychokinetic power.

The baby believes that he can use psychokinetic power. In fact, the doll, Collot, on his back is the one using this power.

Saki brags about her superstrength.

The Princess and the Three Fairies

In order to retrieve the castle that was taken away by the genie, three samurai fairies gather their powers to help their princess.

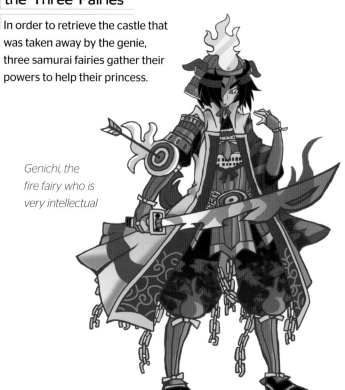

Genichi, the fire fairy who is very intellectual

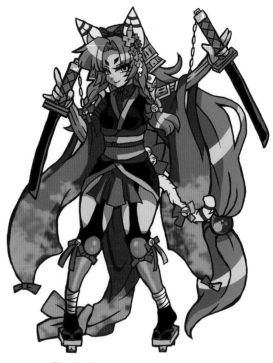

The fox fairy princess who was forced to leave the castle

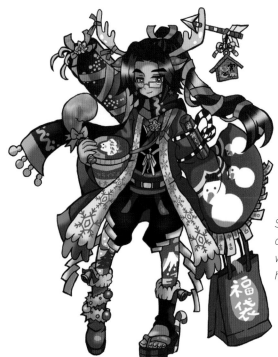

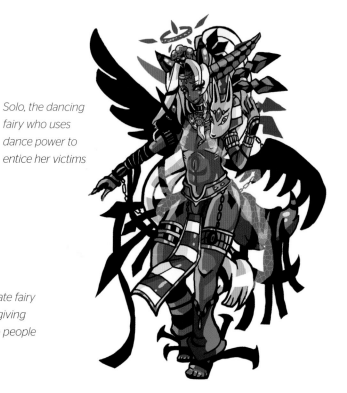

Solo, the dancing fairy who uses dance power to entice her victims

Shuta, the compassionate fairy who enjoys giving happiness to people

The Witch Assistants

These characters, who were once enemies, team up to help Eve, the witch, get her hometown back.

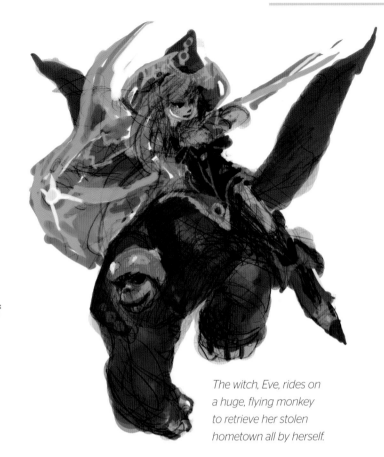

The funny swordsman, June, likes jokes. Eve was his enemy, but he now helps her.

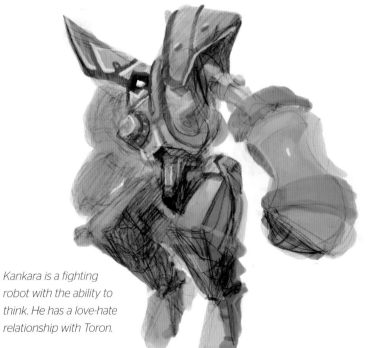

The witch, Eve, rides on a huge, flying monkey to retrieve her stolen hometown all by herself.

Wizard Toron is timid, but has an exaggerated appearance that tries to hide this.

Kankara is a fighting robot with the ability to think. He has a love-hate relationship with Toron.

method 7: combination of various personalities

7の手法

Some characters possess tremendously intense personalities that they cannot adapt to a single group. When these characters encounter each other, they can pull off an unexpected amount of work.

A romantic who believes in the power of music

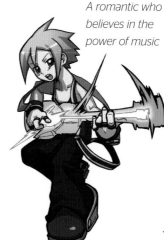

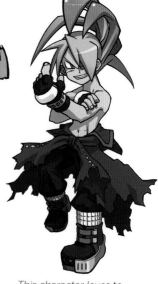

This resourceful character survives in all places of battle. He uses the martial art of fire.

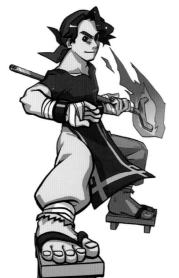

This character loves to quarrel. When he was small, by some unfortunate incident, he became a child fox.

This witty expert possesses extensive knowledge on medicinal herbs, poison, and medicine.

This character is always in a cheerful mood. He is a gifted driver who can manage any kind of operation.

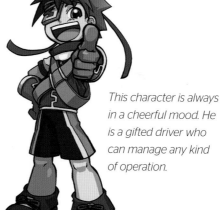

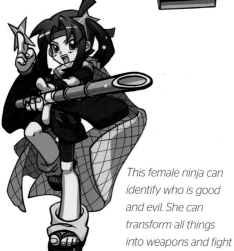

This female ninja can identify who is good and evil. She can transform all things into weapons and fight with them.

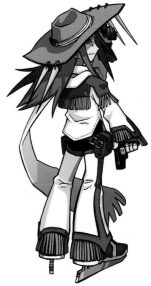

This gunman doesn't usually trust people, but he can recognize a person's kindness.

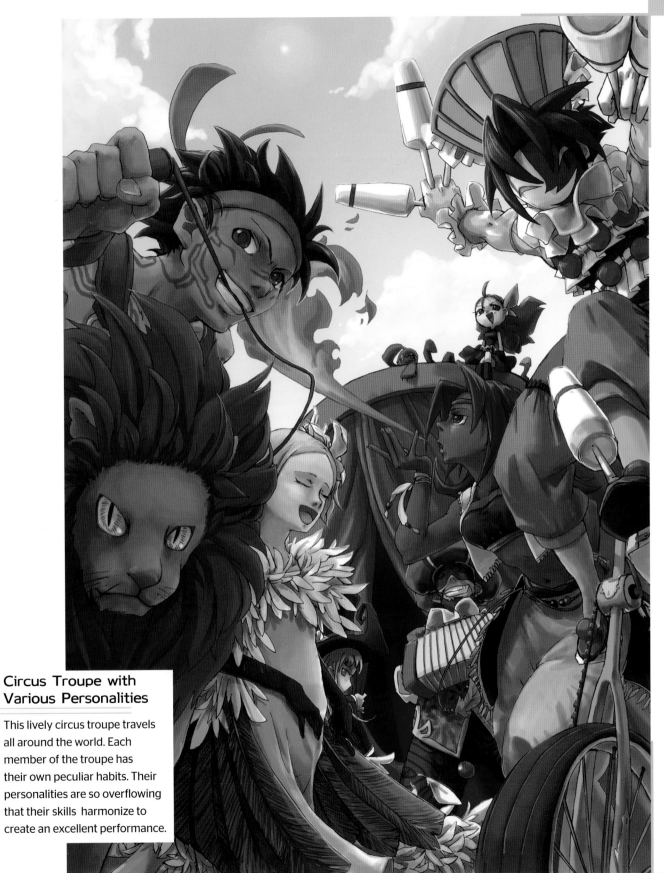

Circus Troupe with Various Personalities

This lively circus troupe travels all around the world. Each member of the troupe has their own peculiar habits. Their personalities are so overflowing that their skills harmonize to create an excellent performance.

Seven Idol Detective Spies

Normally, these characters are idol stars, but they also solve complicated crimes using their portable phones as weapons. They want see each other happy and to know what their own futures hold.

RESOURCE PROCESS

Application of the Seventh Method

The seventh method is not limited to only seven characters, but can also use five, six, eight or more characters, as long as their individual personalities gather in one group. In this illustration, the whereabouts of a precious treasure map is shown in a picture book. The sisters who found the treasure travel with their friends, and their adventurous tale begins.

Index

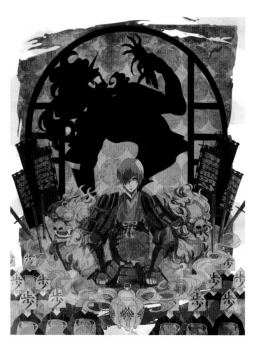

Contributing artists

Front Cover
Mio Okada

Back Cover
Ayaka Ono

Inside Pages
(alphabetical order)
Ai Katayori
Aki Inzan
Aki Seino
Akihisa Mayama
Akiko Houshiyama
Akina Kojima
Akio Yanagida
Anezaki
Asami Ogura
Asuka Takase
Asuka Taniguchi
Atsushi Furusawa
Aya
Ayaka Fujimoto
Ayaka Kimura
Ayaka Tanoue
Ayumu Ueda
Azusa Saito
Chika Ishida
Chittkusol Pongsapat

Chizuru Iwase
Daiki Hirako
Eri Suzuki
Eriko
Eriko Amuro
Etsuko Yamamoto
Fumi Kiyokawa
Fumiko
go
Haruka Kawamura
Hiroko Yamada
Hiroyoshi Tsukamoto
Hitomi Kayama
Ikuyo Otani
Iori Ichinohe
Jiro Arima
Johnson Kim
Kae Ishikawa
Kanako Kakuta
Kazumasa Kato
Kazune Sasahara
Kazuya Matsuda
Kei Juni
Keisuke Kawaguchi
Keitaro Kumazuki
Ken Okada
Kiyomi Enomoto

Kozue Hara
Kuma
Kumi Ando
Mai Goto
Mami Kutsusawa
Mami Nakaji
Marina
Marina Sato
Miki Tanaka
Mio Okada
Misato Yokoi
Moe Shimokobe
Momo Teshima
Monami Komiyama
Nami Mizusawa
Namika Harako
Naoko Oda
Naoto Kajiyama
Natsuki Kamui
Natsuki Ninomiya
Natsuko Manabe
Nonoko Takeda
Nyabibi
Rie Yoshihashi
Rinuko
Saeko Kunimoto
Saika Hiruma

Saika Ono
Saori Matsushita
Sasahara
Satomi Ishii
Satoru Oizumi
Sayuri Mihara
Shihori Terashima
Shuji Gaku
Shunpei Fujimaru
Souto Kuzutani
Tadataka Hidaka
Taichi Kawazoe
TAKORASU
Tatsuaki Minakami
Tomoko Sakauchi
Tsuru Kusakabe
Wasabi
Yanagihara
Yuka Matsumoto
Yuka Nakai
Yuka Yanagihara
Yuki Kawauchi
Yuki Kobayashi
Yukinori Mitsukiyo
Yuzuki Sugiura

Author's profile

Hiroyoshi Tsukamoto
Background in manga, character design, art, and design education spanning over 39 years; continues to train future creators.

Publications
Kyaradezasumasshu ("Character Design Smash"), Graphic-sha Publishing Co. Ltd.
Manga Baiburu 1 - Hikari to Kage no Enshutsu hen ("Manga Bible 1 - Light and Shadow Effects"), Maar Publishing Co.
Kyarakuta Matorikusu ("Character Matrix"), Maar Publishing Co.
Manga Matrix, Harper Design
Manga Baiburu 3 - Suuokumannin no Kyarakuta hen ("Manga Bible 3 - Characters from Billions of Artists"), Maar Publishing Co.
Manga Baiburu 5 - Manga Komawari Eiga Gihou ("Manga Bible 5 - Creating Manga in Movie Frame Style"), Maar Publishing Co.
Manga Kyarazukuri Nyuumon ("Manga Character Making for Beginners"), Kosaido Akatsuki Corporation
Manga no Ougi 1 - Shinwa Densetsu no Sekai to Pentacchi Gihou hen ("Secrets of Manga 1 - World of Myths and Legends, and Pen touch Techniques"), Side Ranch Co. Ltd.

Professional Background
National Cancer Center, Japan, Pediatrics Ward, wall art
Musical "Bollocino," character, stage, and costume design
Yokohama Emergency Center, exhibition illustration
Genshi Adbenkan ("Primitive Adventure Hall"), planning and storyboard
"Lego Land," campaign illustration
Sekai no Otogikan ("World Fairy Tale Hall"), planning and illustration
Nagoya Higashiyama Zoo, Children's Hall, character design
"Kishin Shinoyama Silkroad," LD illustration
Japan Ministry of Construction, city creation and book illustration
Tsukuba Science Expo, "Cosmo Technology Pavilion," character, logo, and pamphlet design; "NTT Pavilion," image illustration
Andersen, illustration and character design
Aichi Expo, competition illustration